A Handbook of
INDIGO
DYEING

Vivien Prideaux

First published in Great Britain 2003

Search Press Limited
Wellwood, North Farm Road,
Tunbridge Wells, Kent TN2 3DR

Reprinted 2007

ISBN10: 0 85532 976 9
ISBN13: 978 0 85532 976 1

Suppliers

If you have difficulty in obtaining any of the materials and
equipment mentioned in this book, then please visit the
Search Press website for details of suppliers:
www.searchpress.com

Alternatively, you can write to the Publishers at the
address above, for a current list of stockists, which
includes firms who operate a mail-order service.

Publisher's note

All the step-by-step photographs in this book
feature the author, Vivien Prideaux,
demonstrating how to create indigo dyed designs.
No models have been used.

To my boys, Duncan and William
to Amanda
to Norman
and to absent friends

Acknowledgements
With thanks to:
Kerry Gilbert of SPINDIGO (Sustainable Production of Indigo
from Plants) for slides of woad;
Long Ashton Research Station, University of Bristol;
John Gillow for the traditional textiles shown on page 9;
Steve Tanner for the photographs on pages 5 and 93, the
background to the back cover and the middle two pictures on
the front cover;
Jenny Balfour-Paul;
Carolyn Wilkins of South West Industrial Crops for the
photograph of the woad project in Cornwall on page 14;
Dor Duncan of the Royal Botanical Gardens at Kew for UK
plant illustrations on pages 14–15;
Wendy Franklin and Jean Hutchins;
Los Ojos Hand Weavers for sharing their bio vat;
Erroll Pires of the National Institute of Design,
Ahmedabad, India;
Siraivddin, dyer, Gat Road, Udipur, Rajasthan, India;
Sophie Kersey for her knowledge and help.

The Publishers and author would like to thank David
and Margaret Redpath for their expertise.

A Handbook of
INDIGO
DYEING

Vivien Prideaux

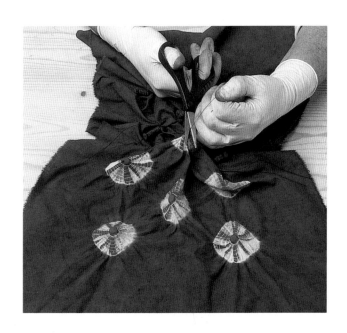

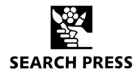

SEARCH PRESS

Vivien Prideaux

CONTENTS

methods of dyeing 44

projects 70

Vivien Prideaux

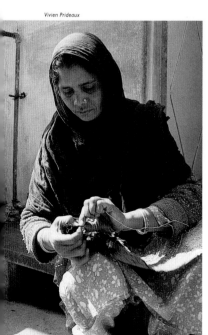

Steve Tanner

INTRODUCTION

As a compulsive colourist and dyer brought up to use man-made dyes, I really did not take to using natural dyes. Mordanting fibres, pans of boiling colours, thermometers... the process seemed such a rigmarole and often achieved only pale, fugitive colours, compared with the quick and easy dyeing method used to produce the amazing colours of fibre-reactive dyes.

When I first made an indigo vat, some fourteen years ago, it was just for the experience, to see how the shaped resist techniques called 'shibori' by the Japanese would look in their original colour – indigo blue. I shall never forget that wonderful day: not only was the weather wonderful: hot, sunny and still – it was just the most exciting dyeing process, with terrific results, that has continued to excite my imagination ever since and changed my opinion of natural dyes. Since that day, there have been years of experimentation, excitement, frustration and fun as I have shared the experience with friends and students.

The practice of dyeing with indigo is an incredibly rich cultural tradition, with each region of the world having its own unique methods and beliefs, and even religious ceremonies, as part of the process. I find the dyeing routine – the process of fabric preparation, planning, drawing, hours of hand stitching, revising and testing – so satisfying. Look upon dyeing as an art, not just a technique.

This book comes out of my passion and respect for the patterns and effects that are obtainable through the combination of resist techniques, stitching and the indigo vat. The sample shibori techniques demonstrated should form the building blocks with which you can create pattern and texture on natural fibres.

The recipes for this 'king of colours' have emerged from my travels in South America, the Middle East and India and my research into indigo dyeing in Africa and Japan. Hopefully they will encourage the reader to have a go, experiment, play and enjoy the many and varied shades, patterns and results that can be obtained from this most noble of dyes.

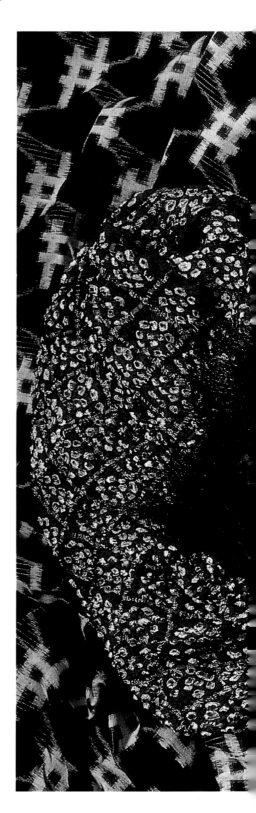

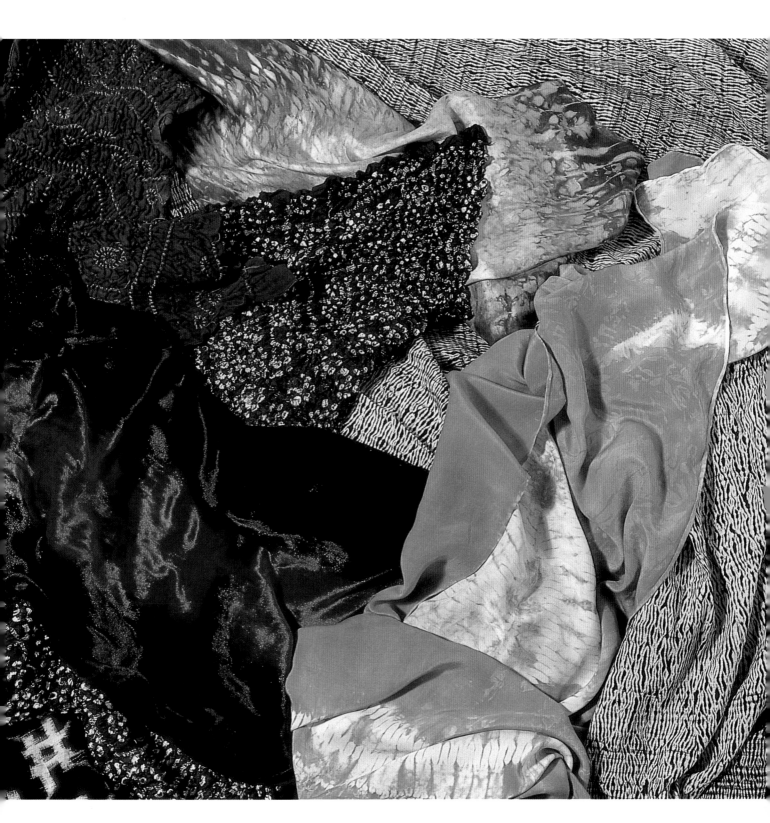

HISTORY

Until 1856 when the eighteen-year-old William Perkins discovered Mauveine by chance while working on a treatment for malaria in his London laboratory, the best substantive colour-fast dye in commercial use was indigo blue.

Fermented or bacterial indigo has been used as a dye for thousands of years. It was discovered long ago that if indigo leaves were left to rot in urine, colour was released and a green solution was created. Natural fibres, when soaked in the green solution, would turn from green to blue in the air. Each region of the world developed its own dyeing methods and traditions from this process.

Wonderful fabric survives from the Egyptian tombs dating from around 2400 BC: linen woven with fine indigo dyed borders. References to blue cloth being traded by the merchants of Sheba (now known as Yemen) can be found in the Old Testament. In ancient Israel and Palestine, indigo was combined with green and black dyes. The arid climate of Atacama in northern Chile and Peru has preserved lengths of highly technically woven double and treble-faced cloths, known collectively as 'amarras'. These embroidered, tie-dyed and indigo-dyed cloths were found in graves in this desert region and are now in the collections of the Museum of pre-Colombian Art in Santiago and at the University of Antofagasta in Chile.

The humid climate of parts of Asia is destructive to natural fibres, so few artefacts survive, but the Victoria and Albert Museum in London has a fine collection of indigo fabric fragments dating from the Han to Tang dynasties (618–906AD) in China.

The wool and cotton tie-dye resist fabrics found in the burial caves of Mali, West Africa, date from the eleventh to the sixteenth centuries and are very similar to the indigo-dyed cloth still produced by the Yoruba people of Nigeria today.

The dyers and weavers of Europe in the Middle Ages used woad (*Isatis tinctoria*), that was grown locally in abundance to supply the flourishing weaving industry. The large, beautifully carved wooden houses once owned by woad merchants in Toulouse survive today as testament to the success of the woad trade in France, which was then the main source of blue dye. Non-native indigo in the form of *Indigofera tinctoria* was imported into Europe, but since it made its way there along the precarious, often war-torn Silk Route from Asia, it was very expensive.

Woad was the main source of blue dye in Europe until 1498 when Vasco da Gama rounded the Cape of Good Hope,

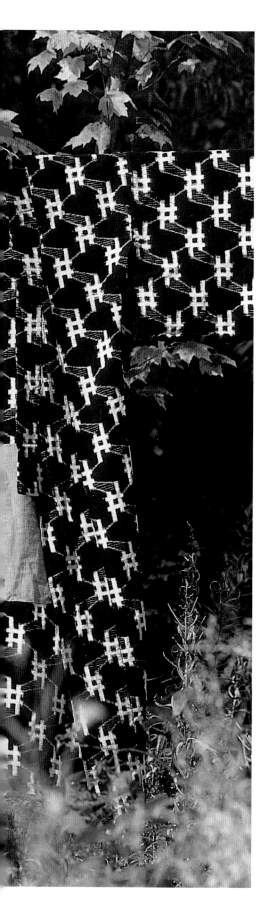

setting in motion the beginning of world trade. With the increase in trade with India, Asia and South America, the woad industry began its slow decline. In France at the end of the eighteenth century, attempts were made to confine dyers to the use of woad, by threatening them with the death sentence if they were found to be using indigo. This law has never been repealed! However, the decline of woad was unstoppable: the last commercially grown crop in mainland Europe was harvested in 1887 and the last woad mill was closed in 1912.

In England, woad was grown commercially until the sixteenth century to reduce imports from Italy, France and Germany. With the increase of imports, mainly from India, woad died out as a major crop in the middle of the eighteenth century, but continued on a small scale, since woad indigo was used to mix with imported indigo in order to improve the fermentation process. It continued to be grown as a specialised crop in Lincolnshire until the Second World War, where it was used to dye the uniforms of the Royal Navy, Royal Air Force and police.

Following the Second World War, the decline of the textile industry in the West resulted in the demise of woad as a commercial crop.

Today, increased awareness of the need for bio-diversity and consumer demands for more environmentally friendly materials have resulted in a five-year feasibility study into the commercial growing and extraction of indigo from woad. Trials continue in the UK, Germany, Italy, Spain and Finland. Indigo grown in the UK is being used by a leading London fashion house for clothing designs launched during London Fashion Week. The future could be bright for natural indigo!

The warp and weft cotton threads of this kimono were bound and dyed before being woven.

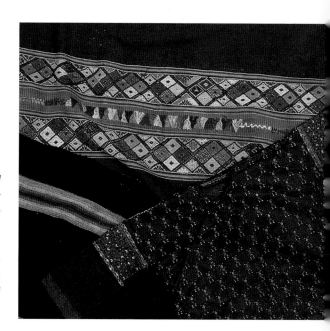

Top: an indigo dyed embroidered manta, or woven shawl and left: a manta dyed with indigo, cochineal and safflower; both from Peru. Right: a Chinese child's coat woven and overdyed with indigo.

HEALTH AND SAFETY

It is important to remember that any chemical can be dangerous, so you should establish good, safe standards of studio practice from the start. I have experimented, and you may wish to do so as well, but please be careful and use the dye recipes and chemicals sensibly. Take all the precautions listed below to protect your health, and then you can relax and work in comfort and safety. The range of dyes and associated chemicals used in indigo dyeing will present very little risk to health and to the environment, providing the following instructions are always observed.

- Always read the full instructions and gather together all the necessary equipment, dyes and chemicals before starting the dyeing process.
- Always wear heavy-duty rubber gloves. I buy perm gloves from my local hairdresser. These have the advantage of being sized, and they are more resistant to chemicals than ordinary rubber gloves. I also use long, heavy-duty industrial gloves for dyeing in the larger vat.
- Always wear a full front-covering apron, overall or lab coat.
- Always wear a particle face mask when handling dry powders or granules, to avoid inhaling either of these.
- Safety spectacles with transparent sides will provide eye protection.
- Always work in a well-ventilated area, on a clean, dry work surface.
- Avoid getting dyes or chemicals on your skin. Should this happen, simply wash off with water immediately.
- Indigo can be messy, so keep an old towel ready to wipe your hands on, and if you do have to wipe the dye off surfaces, use a kitchen cream cleaner.
- Dye-pots, spoons, measuring jugs, scales or any other equipment used to work with dyes and chemicals should never be used for any other purpose, especially the preparation of food.
- I never use dyes in a microwave oven and do not advise it.

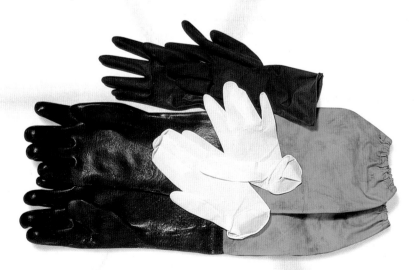

Safety spectacles with transparent sides for eye protection.

A particle face mask must be worn when you are handling dry powders or granules.

Keep an old towel handy when dyeing and use kitchen cream cleaner to wipe surfaces.

Hairdressers' perm gloves, heavy-duty rubber gloves and long heavy-duty industrial gloves used for dyeing.

- Always store dyes and chemicals in well-marked containers in a cool, dark place, away from children and pets.

All dyes and chemicals must be stored in well-marked containers.

Take particular care and wear rubber gloves, a mask and eye protection when handling the following chemical substances:

Zinc, Zn
Zinc has to be handled with care as it can be highly inflammable when mixed with air.

Calcium hydroxide, Ca(OH)$_2$, also known as hydrated lime or slaked lime
This pale powder will burn if it comes in contact with the skin.

Ammonia, NH$_3$
Ammonia is used as an aid to dyeing protein fibres. It evaporates during drying. Do not inhale the vapours. Keep in an airtight, well-marked bottle in a cool place.

Sodium hydroxide, NaOH, also known as caustic soda
Always put caustic soda into water, never pour water over caustic soda. This chemical is corrosive and will cause burns if it comes in contact with skin or eyes. Store in a well-marked container in a cool place.

Sodium hydrosulphite, Na$_2$S$_2$O$_4$, sold as Colour Run Remover; and sodium dithionite
These chemicals are corrosive and will cause burns if in contact with skin or eyes. Always add powder to water, not water to powder. Keep the powder in an airtight container as it degrades when in contact with air. Always use a dry measuring spoon and avoid getting any water drops in the chemical, as this could result in spontaneous combustion. If the smell has gone, the powder will not be viable and you should buy fresh.

- If you decide to dispose of the contents of a zinc lime vat rather than pass it on to another dyer, contact your local environmental services, as the liquid will contain small amounts of zinc. To dispose of a spent hydrosulphite vat, exhaust the vat completely by leaving an old piece of fabric in it for twelve hours or more. Then whisk the remaining liquid to exhaust any remaining reducing agent. Then dispose of the solution down the toilet. Other vats can also be disposed of down the toilet, if you flush well. Small amounts of reactive dye can be disposed of down the drain. Flush well with clean water. Alternatively you can keep these dyes in well-marked containers and use them for painting in your sketch book – they make brilliant colours.

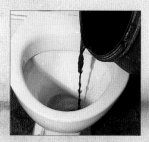

A hydrosulphite vat, once exhausted according to the instructions (left), can be disposed of down the toilet.

MATERIALS

FIBRES

All natural fibres dye well in indigo. Most other natural dyes need a mordant – a chemical agent that assists in attracting dye into fabric. Indigo, however, is a substantive dye, and there is no need to mordant your fabric prior to dyeing.

When it comes to fabrics, I am like a magpie, collecting any natural fabric with a weave that catches the light (such as flat satin silk), has drapability (crepe de Chine) and texture (silk, velvet, silk noil, pineapple fabric and linen). Wool crepe and arctic wool gauze respond well to clamping and pole wrapping preparation techniques (see the Shibori section on page 22). Felted wool and shibori could provide another lifetime's exploration! I especially enjoyed dyeing knitted hemp made from hemp grown in Cornwall, with woad also grown in the county. Each fabric and fibre will give a different feel to your work, so experiment and keep notes of your findings.

Natural fibres fall into two categories: protein and cellulose. The difference between the two is easy to remember: if it walks, it produces a protein fibre; in other words, protein fibres come from animals. If it grows, it produces cellulose fibres – these come from plants.

Protein fibres are not as tough as cellulose fibres and need different treatments in the dyeing process. The main difference is that, given the same amount of fibres, protein fibres take up far more of the oxidised indigo than cellulose. If pieces of silk and cotton of equal weight are dyed for the same length of time, the silk will take up more dye and will end up a darker blue than the cotton. Repeat dippings will not harm cellulose fibres, but can damage protein fibres. Despite these differences, I have not encountered any problems using either fibre in any of the indigo vats, provided that the instructions are followed carefully, particularly with respect to timing.

I enjoy collecting different fabrics and experimenting with preparation and dyeing techniques to decorate them.

CELLULOSE FIBRES

Cellulose fibres are obtained from plants and include mercerized and unmercerized cotton, muslin, percale, linen (flax), jute, hemp, ramie, rayon and viscose (derived from wood pulp), pineapple fabric and many others.

Cotton and other cellulose fibres contain a natural waxy substance which acts as a natural resist, so the fibres need to be scoured by boiling before dyeing (see page 20).

A cellulose vat is cold and the alkalinity is much lower than for a protein vat. There is a recipe for an indigo vat especially suited to the dyeing of cellulose fibres on pages 62–63.

Cellulose fibres after a two minute dip in a hydrosulphite vat. Top row: linen and cotton organza. Middle row: cotton voile and knitted hemp. Bottom row: pina cloth and crepe cotton.

PROTEIN FIBRES

Protein fibres and fabrics include wool, mohair, angora, llama and alpaca. These contain oil and lanolin that must be removed by scouring before dyeing (see page 20).

Silk is also a protein fibre and should be scoured because raw silk contains a protein oil called sericin that is secreted by the silkworm. Firstly, check that the silk you buy has been degummed. Then scour it to remove oil and starch, leaving it ready for dyeing (see page 20). Alternatively, you can buy pre-scoured silk.

There is a recipe for an indigo vat especially for the dyeing of protein fibres on pages 62–63.

Protein fibres after a two minute dip in a hydrosulphite vat. Top row: silk crepe and crepe de Chine. Middle row: silk velvet and tussah. Bottom row: wool chalice and wool felt.

INDIGO

Plants of the species Indigofera, Polygonum, Lonchocarpus and Isatis, containing the chemical compound indican in their leaves have been grown for thousands of years. Indigo-bearing plants have mostly been grown in tropical climates, apart from woad (*Isatis tinctoria*), which was grown commercially in Europe from medieval times until the early twentieth century.

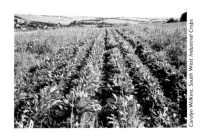

The graceful form of *Indigofera tinctoria* with its light green foliage and pea-like flowers gives no clue to the wonderful strong blue dye that can be obtained when the leaves are set in a vat of water and allowed to ferment. This process releases the indigo proper from its primary state of indican. The resulting paste is dried and formed either into blocks, balls or thin sheets, or ground into a powder, which is insoluble until it is activated in an indigo vat.

PLANTS

Indigofera tinctoria

This was named and described by Linnaeus in his *Species Plantarum* of 1753. It belongs to the Leguminosae family, a genus of seven hundred or more species of evergreen or deciduous trees and shrubs, annuals and herbaceous perennials, widely distributed in tropical and subtropical regions of the world, in a variety of habitats. This shrub, which grows to a height of between four and five feet, was originally native to India, China, Indonesia and northern parts of South America. I have successfully grown *Indigofera tinctoria* in my garden in Cornwall.

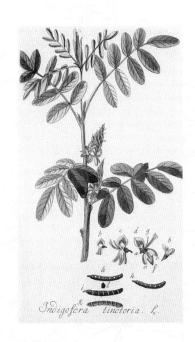

Isatis tinctoria (woad)

Woad is very easy to grow from seed and quite easy to extract, although I have found the resultant blue from my own attempts at extraction disappointing for the time and effort involved. Fresh leaves from the first year's growth should be used, since frozen or dried leaves will not yield the indican needed for dyeing. A ratio of 1:4 weight of dry fabric to fresh woad leaves will give a darkish blue.

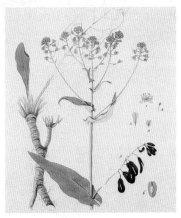

Polygonum tinctorium

Also known as Japanese indigo, Chinese indigo and dyers' knotweed, this indigo-bearing plant is often grown alongside *Indigofera* in China and Japan. In Japan it is widely cultivated and is known as *Ai*. The extraction process is the same as for woad. A frost-tender annual, it can be grown in a warm, humid climate and fertile soil. Sow seed in the spring indoors or in a greenhouse. It germinates well and can be planted out 20–30cm (8–12in) apart, or in a large pot after the last frost. Keep well watered, even in open ground. When the plant reaches 30–60cm (1–2 ft) tall, and a bruised leaf turns navy blue, it is ready to harvest. This is usually between July and September. The recipe for dyeing using indigo extracted from this plant is on page 67.

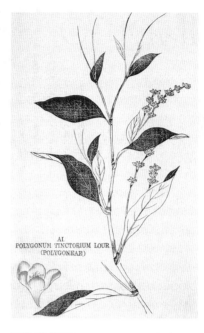

AI
POLYGONUM TINCTORIUM LOUR.
(POLYGONEAE.)

Lonchocarpus cyanescens

In Western Africa the Yoruba people use *Lonchocarpus cyanescens* to dye their intricate paste resist cloths in contrasting pale and dark blues.

I buy natural indigo in the form of powder from importers, or when on my travels, I buy as much as I can carry in bazaars. Sieve the powdered indigo through a fine ceramic mesh to ensure that it is fine enough, and to remove any impurities if the indigo was bought in a market or bazaar. If your indigo is in the form of blocks, balls or sheets, grind it to a fine powder using a pestle and mortar.

Natural and synthetic indigo are chemically identical, although the impurities in natural indigo can give slight differences in dyeing behaviour and resultant tone. I use double the weight of natural indigo to synthetic indigo, and since synthetic indigo is half the price, I tend to use this, except in the bio vat (see page 65).

Synthetic indigo can be obtained as 100% indigo microperle or as indigo vat 60% grains. The latter contain semi-reduced indigo, so less reducing agent is needed.

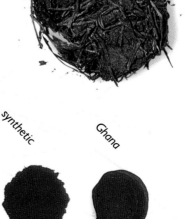

Mali (yroba)

woad

60% indigo grains

Rajasthan

Morocco

synthetic Ghana

OTHER MATERIALS

DYEING EQUIPMENT

I buy my materials from a variety of outlets. My local hardware store stocks a comprehensive range of suitable containers in every size, thermometers, G clamps and scales as well as caustic soda, ammonia, washing soda and methanol. Calcium hydroxide is sold as hydrated lime by builders' merchants. Other chemicals can be bought from dye specialists.

Dye recipes often call for a % solution. Calcium hydroxide 10% solution is made by dissolving 100g (3.5oz) calcium hydroxide in 1 litre (35.2 fl oz) of water. Ammonia 25% solution is 250ml (8.8 fl oz) of shop bought ammonia dissolved in 1 litre (35.2 fl oz) of water.

Sodium hydroxide, NaOH, caustic soda
This strongly alkaline solution, also known as 'soda lye' is used in an indigo vat for cellulose fibres. I use a 25% soda lye solution.

Sodium hydrosulphite, Na$_2$S$_2$O$_4$
A strong reducing agent used for chemical fermentation, this comes as a fine white powder with a curious smell. Sodium hydrosulphite is sold in supermarkets as Colour Run Remover for washing.

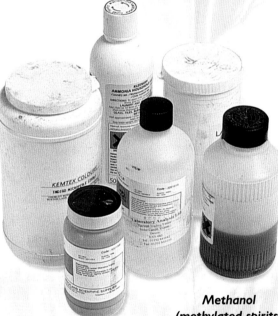

Methanol (methylated spirits)
Used to dissolve indigo powder

Calcium hydroxide, Ca(OH)$_2$, hydrated lime
This pale powder is used as the alkaline additive to a zinc lime vat.

Washing soda
Used for scouring cellulose fibres, and as part of the hydrosulphite vat

Ammonia, NH$_3$
The alkaline qualities of ammonia gas in water are used for dyeing protein fibres. Ammonia replaces caustic soda in the basic bath – it is kinder to fibres and evaporates during drying.

Zinc metal dust, Zn
Used as a reducing agent. Handle with care as it can be highly inflammable when mixed with air.

Safety Note
Refer to the safety notes on page 11 when using chemicals.

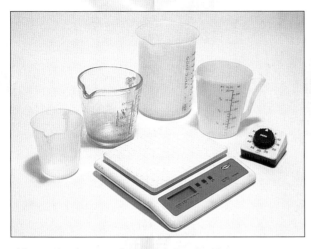

Measuring jugs, scales and timer

Pure soap, vinegar, salt, gelatin, sugar, urea, bran, septic tank starter and pH paper
Used for various dyeing recipes. Gelatin counteracts the tendency of indigo to precipitate in the vat and become inactive. Salt helps indigo particles to attach to fibres.

Selection of stirrers

Thermometer

Kitchen foil
Used to wrap fabric for steaming

Plastic food wrap
For covering the stock solution

Pestle and mortar
Used for grinding indigo blocks, balls or sheets.

Plastic container, glass jar, plastic jug and stainless steel bowl

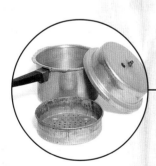

Pressure cooker and steamer
Used to create a double boiler and for steaming

Stainless steel bucket
Used for the hydrosulphite vat

Plastic vat with lid

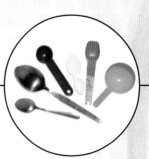

Spoons for measuring

MATERIALS FOR FABRIC PREPARATION

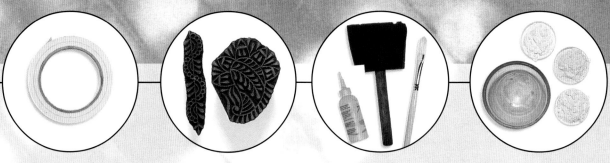

Masking tape
Used in pole wrapping

Printing blocks, a bottle with a fine nozzle, a sponge brush and a brush
Used for applying paste resists

Paste resist ingredients
Plain flour, rice flour, powdered laundry starch and a mixing bowl

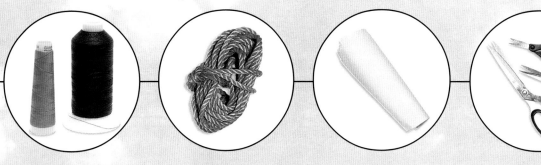

Strong polyester thread
For stitching and binding

Rope
Used as a core around which to wrap fabric

Tissue paper
Used during the steaming process

Scissors

Pegs, string and bulldog clips
Used for clamping and tying fabric

Pieces of drain pipe
Used for pole wrapping

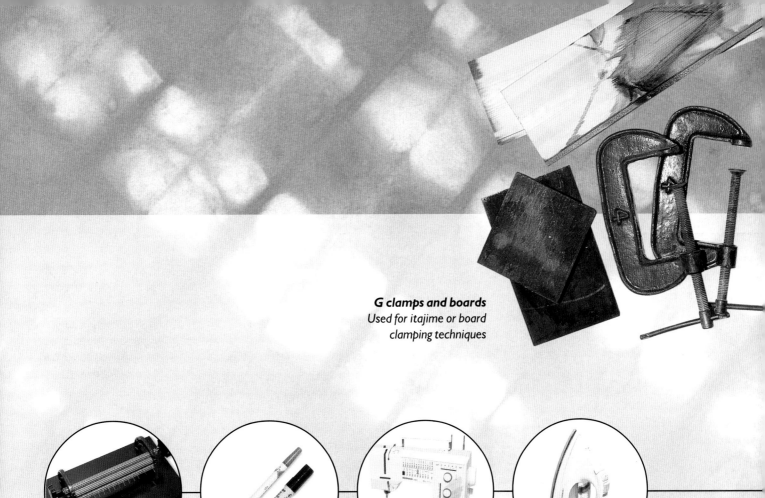

G clamps and boards
Used for itajime or board clamping techniques

A pleating machine

Water soluble and permanent marker pens
Available from most haberdashery shops

Sewing machine

Iron

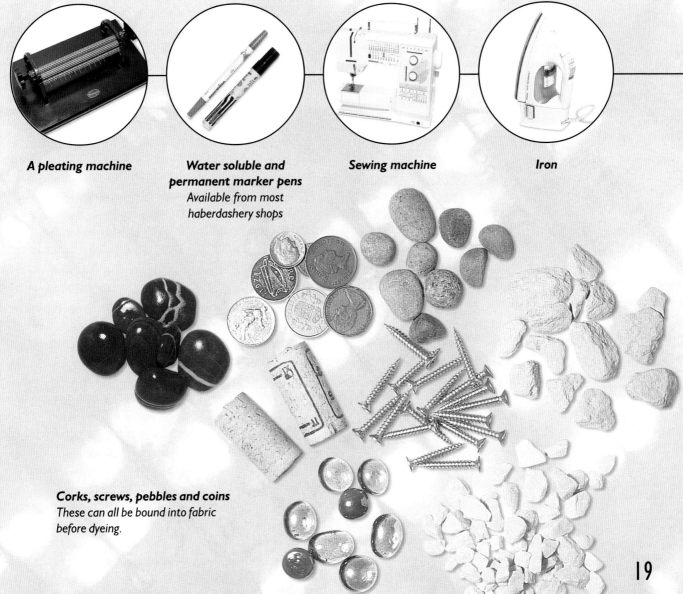

Corks, screws, pebbles and coins
These can all be bound into fabric before dyeing.

PREPARING FABRIC

PRE-WASHING

Wash and dry all fabrics before dyeing, to remove excess dressing. After pre-washing and before dyeing, soak cotton, linen, viscose or rayon and other cellulose fibres in water for about ten minutes. Silk and wool should be soaked in warm water for about twenty minutes. Loosely woven fabrics should be stitched along the edges before washing, to prevent fraying and unravelling.

PRE-WASHING FABRICS

Protein fibres and fabrics such as **wool, mohair, angora, llama** and **alpaca** should be scoured for thirty minutes or overnight in a solution of warm water, 40°C (105°F), containing a small amount of pure soap. Rinse well but gently in warm water (vigorous washing will cause the wool to felt). Squeeze out the excess water. Dry. If the protein fibre or fabric is very oily, you may have to repeat this process.

Silk fibres or fabric should be washed gently for about ten minutes in warm water containing a small amount of pure liquid soap. Rinse well but gently and squeeze out the excess water. Never boil silk as it destroys the fibres and dulls the natural lustre of the fabric.

Cotton and other **cellulose fibres** should also be scoured. Working in a well-ventilated place and wearing rubber gloves, fill a large stainless steel container with water and add a good handful of washing soda and a small amount of pure soap. Ease the fabric into the liquid and boil for thirty to forty minutes. Allow to cool, then rinse well. Alternatively, put your fabric in the washing machine, add a good handful of washing soda and pure soap and run on the hottest, longest wash.

PRE-WASHING YARN

It is important when scouring and dyeing yarn, either protein fibres such as wool or silk or cellulose fibres such as cotton, that the hanks or skeins are tied loosely in about three places to avoid tangling.

Scour silk yarn overnight in a pure soap solution, rinse well and gently squeeze out the excess water. Dry the skein or if you are dyeing straight away, let it drain for about five minutes or so before beginning.

Cotton or other cellulose fibres are less sensitive than protein fibres and should be scoured by boiling for forty-five minutes in a pan of water containing a tablespoon of washing soda. Rinse well before dyeing.

Wool must be free of oil or lanolin, or the indigo will not penetrate the yarn. Scour wool overnight in a pure soap solution, rinse well and gently squeeze out the excess water. If the wool is very oily, you may have to repeat this process. Dry the hank or if you are dyeing straight away, let it drain for about five minutes.

Scouring silk yarn and fabric in a pure soap solution

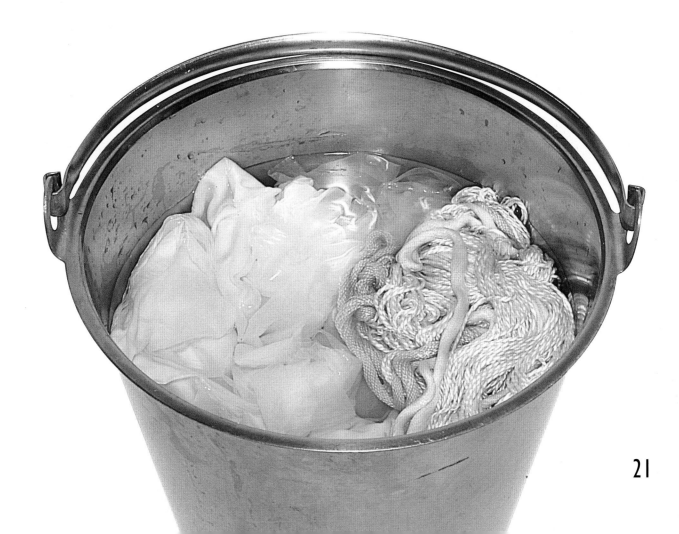

SHIBORI

Shibori is the Japanese collective word for various types of shaped resist produced by manipulating fabric – securing it with stitching, binding or clamping – before dyeing. Fabric may be drawn up and bound; stitched and gathered up; pleated and bound; folded and clamped between boards, or wrapped around a pole, and then pushed along it, compressing the fabric into folds. Furthermore, fabric may be dyed repeatedly, using a different shaping method and a build-up of colour. In fact, any pressure on fabric that does not destroy it will produce a mark.

The shibori process works in a three-dimensional way on a two-dimensional surface, and you can use the positive and the negative, the front and back of the fabric, the interaction between the manipulated and the plain areas, and the proportions of dark and light to produce dynamic, subtle effects.

Keep detailed notes for future reference, as this process provides a lifetime of experimentation and thrilling results.

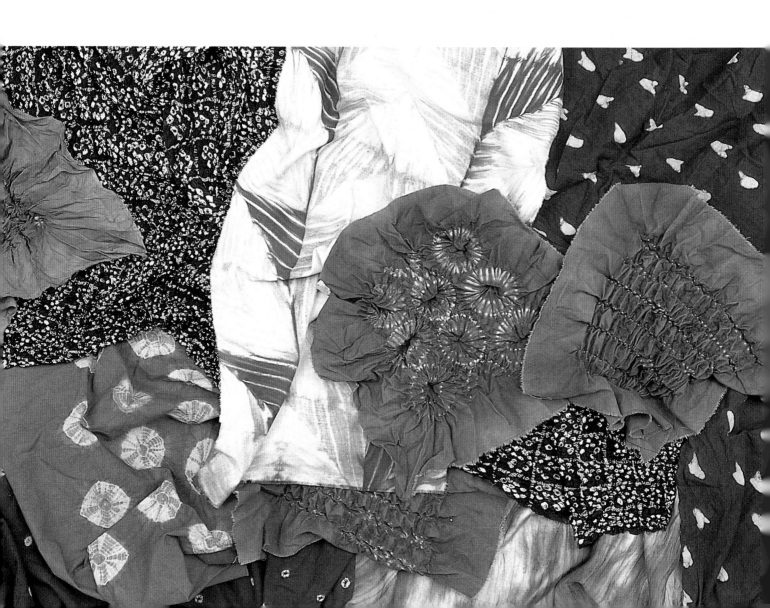

ITAJIME – BOARD CLAMPING

Itajime is a method of dyeing fabric by folding it in two or more directions into a neat bundle, then clamping the fabric between two boards. The pressure of the clamp will vary the colour take-up. The shape of the two boards will also vary the pattern. The variety of effects you can produce using this technique is endless, considering the variables of fabric weight and weave, the size and frequency of folds, the size and shape of boards and the position and amount of pressure applied. Kikko folding can be used in conjunction with board clamping, as shown below.

KIKKO FOLDING

Tortoiseshell patterns made from hexagons are traditional in Japanese textiles. Kikko folding also produces snowflake-like patterns that remind me of my childhood. The following project includes both board clamping and kikko folding.

You will need:

Two pine boards, 10 x 25cm
(4 x 10in)
Fabric
G clamp

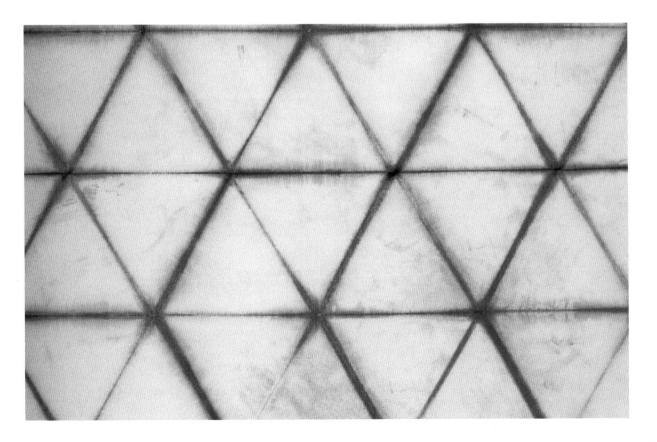

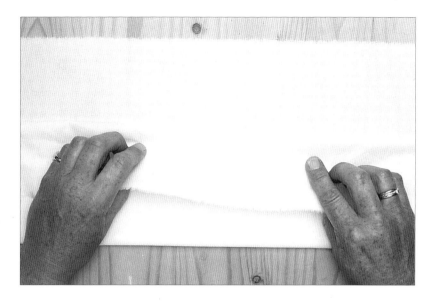

1. Fold the fabric lengthwise into accordion pleats. The size of the finished pattern can be altered by the width of the accordion pleats: large pleats give a large pattern, small pleats gives a small pattern.

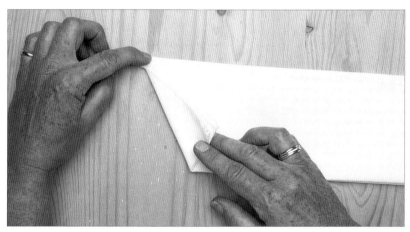

2. To make the triangular kikko pattern, first lay your pleated fabric flat on your work surface in a vertical alignment. Place your left index finger securely on the top left corner of the pleated fabric, and taking the bottom left corner in the finger and thumb of your right hand, fold that corner forward and up, so that the fold exactly halves the resultant angle now existing at your left index finger.

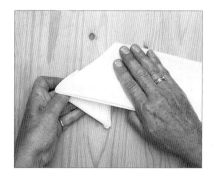

3. The portion of the left-hand edge of the fabric which has been folded forward and up, can now be seen to be forming half the base of an equilateral triangle, with the apex at your left index finger. Imagine a dotted line completing that base, and fold the whole of the equilateral triangle of fabric backwards and under, along that dotted line or base.

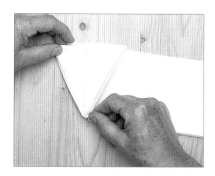
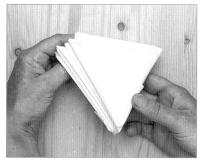

4. Turn the whole piece of fabric over to reveal your folded over equilateral triangle. Fold this under along the diagonal, and turn the whole fabric over again.

5. Continue this process of turning over the fabric and folding the triangle backwards and under, until you get to the end and find yourself with half of an equilateral triangle left sticking out to one side. This is equal to the first fold you made, so fold it over to mirror your original fold.

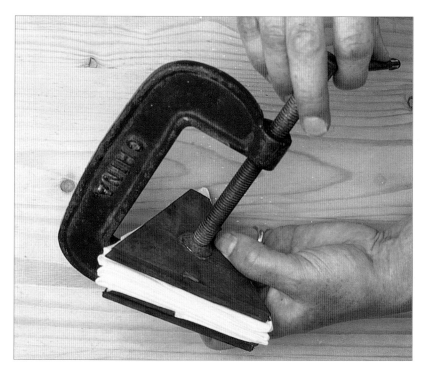

6. The stack of fabric is then clamped between boards and held in place with string or with a G clamp as shown here. The size of board used for clamping will affect the resulting pattern, so experiment with different sizes and shapes of board. You can add buttons or coins in between the fabric and the boards to pattern smaller pieces of fabric. Before dyeing, submerge the folded, clamped fabric in water, so that it is thoroughly wet. Squeeze out surplus water before dyeing.

Note

After dyeing, if you are happy with the depth of colour, remove the G clamp and boards and hang the fabric on the line, opening all the folds to ensure oxidation. Leave to air dry for as long as possible, then wash. If a darker shade is required, leave the boards and G clamp in place, allow oxidation to take place and re-dip after about half an hour. The boards should be washed after use, to avoid cross-staining subsequent fabric.

STITCHED AND GATHERED SHIBORI

For stitched shibori, you should use thread that is of a weight appropriate to the fabric and strong enough to be pulled tight and knotted off without breaking. I use a polyester thread, which I get from my local work wear manufacturer; end of cops in horrid colours for very little cost. You can also pick up oddments from car boot sales. The cottons you have in your thread box are unsuitable as they tend to break very easily. Simple running stitch is used in most shibori, apart from over-stitch which is used for the chevron stripes pattern shown on page 35.

Mokume

Mokume in Japanese means wood grain. The balance of light and dark colour gives the fabric a textural effect similar to the grain patterns found in wood. Traditionally, the stitching is done across the fabric because this requires a shorter length of thread, but the stitching can be done in any direction, with each row of stitching parallel. You use one continuous thread for each row.

I often use a 24-row pleating machine to gather my fabric. This allows me to gather long lengths of fabric much more quickly than if I stitch by hand. To save breaking the needles of the pleating machine, I always add fabric softener to the final rinse when pre-washing fabric, then wash the gathered fabric again before dyeing.

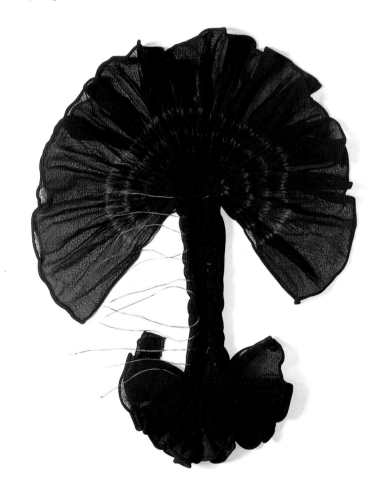

This machine-gathered mokume scarf, made from silk crepe georgette, has been partially unpicked to create this interesting shape.

Hand-stitched mokume

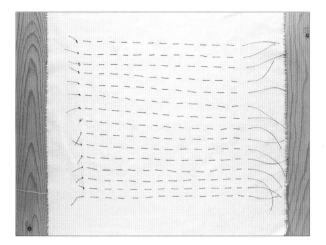

You will need:

Strong thread

Needle

Pre-washed natural fabric

Scissors

1. Knot the end of a thread and sew a straight line across the fabric. Cut off the thread, leaving a bit of loose end. Repeat this process all the way down the fabric in straight lines, as shown.

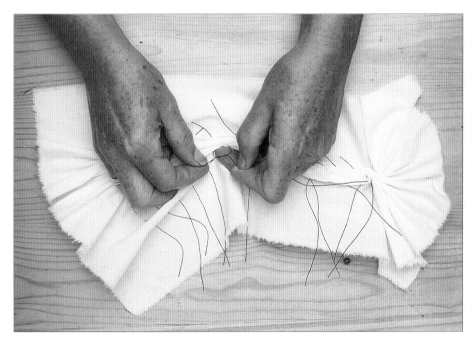

2. Pull up the loose ends on the opposite side to the knotted ends as tightly as possible, pushing the fabric towards the knots. It is this process of tying the fabric very tightly that produces the pattern. Loosely tied fabric will result in a less defined pattern. Knot the loose ends of the threads. The fabric is now ready for dyeing.

Note

Vary the effect by altering the distance between rows or the length of stitches – you can stitch random lengths. You can also work within a shape.

Mokume using a pleating machine

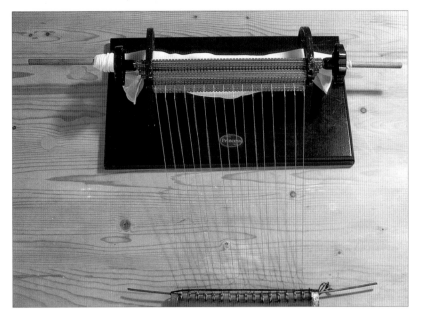

You will need:

Thread

Scissors

24-row pleating machine

Silk crepe georgette scarf

Note

Pleating machines are usually used for short pieces of fabric for the smocking on children's clothes. When pleating a longer piece like this, I thread the bobbins on to a length of coat hanger wire, to prevent the threads from tangling.

1. Thread the needles of the pleating machine. Wind the silk scarf round the pole and feed the end of the silk through the reels of the machine.

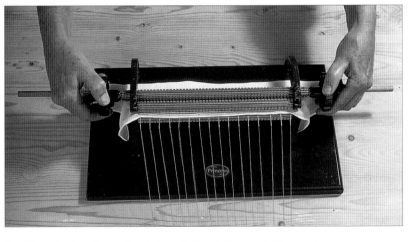

2. Turn the knobs to feed the silk fabric through the reels.

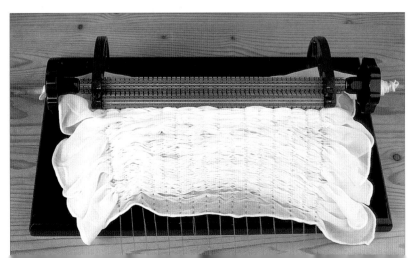

3. As the scarf feeds through the machine, ease the fabric through the rollers and down the threads. The fabric will be smocked in lovely neat rows.

28

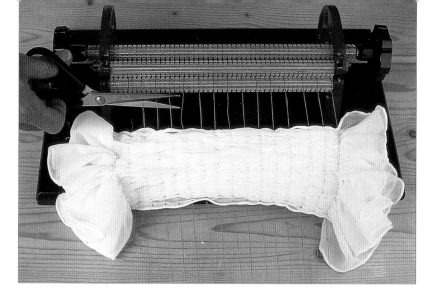

4. Push the smocking down on to the threads. Cut the threads off the needles and the bobbins.

5. Knot the loose ends of the threads on one side and pull the smocking tight.

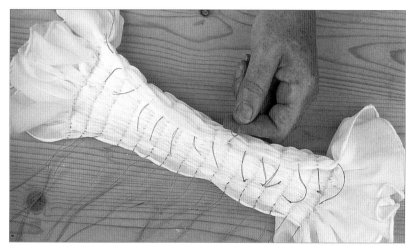

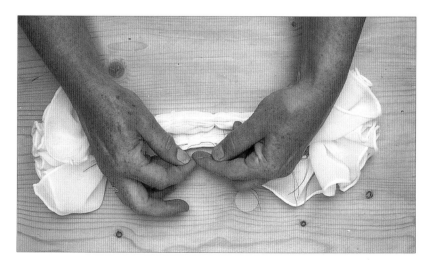

6. Knot the other ends of the threads. The fabric is now ready for dyeing. You can see this piece being dyed on page 60. After dyeing, hang the pleated fabric up to dry for as long as possible, making sure you open up the pleats to ensure oxidation. Remove the stitching and wash. Add vinegar to one of the rinses to protect the silk from the alkalinity of the vat. If a darker shade is required, leave the stitching in place and re-dip after drying for half an hour.

Note

You can vary the effect when using a pleating machine in a number of ways. Vary the spacing of the pleating by changing the position of the needles, or pleat the fabric on the cross grain. Work only part of the fabric, or pleat it in one direction, dye and wash it, then pleat it in the opposite direction and dye it again.

BINDING OBJECTS INTO FABRIC

Wonderful patterns can be produced by binding or stitching any object into the fabric before dyeing. Collect stones of all shapes and sizes, marbles, shells, buttons, beads, screws, rice, peas, sticks, shards of pottery – in fact anything you fancy.

You will need:

Pre-washed natural fabric
Screws or other objects
Water soluble pen
Strong thread

1. Plan your design and, using a water-soluble pen, mark the position of each object (in this case, screws) on your fabric. You can vary the spacing and the density of the pattern, or work within a design.

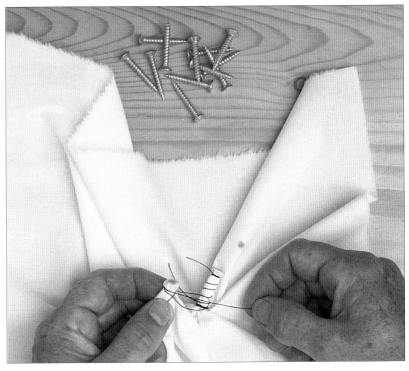

2. Put the head of a screw behind one of your marks and knot the thread around it using a clove hitch.

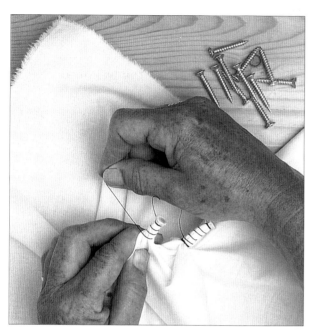

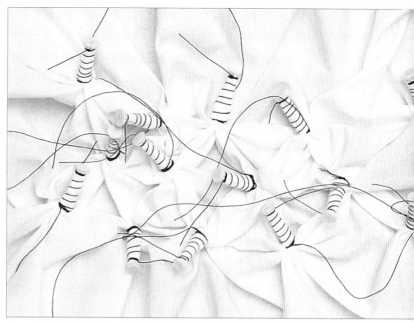

3. Wind the thread around the whole length of the screw, finishing with a clove hitch.

The fabric ready for dyeing

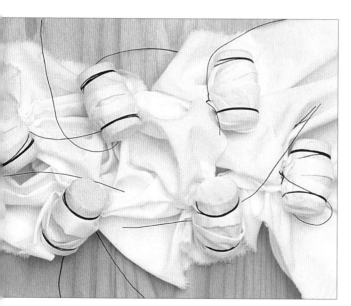

Corks bound into fabric in a similar way

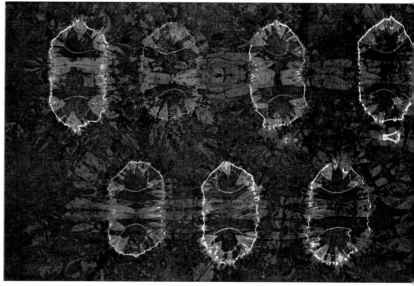

The cork-bound fabric after dyeing

FOLDED AND STITCHED SHIBORI

Stitching through a fold of fabric produces intricate symmetrical patterns. Squares, rectangles and diamonds can be created in this way as well as various types of stripes.

Ori nui

This is an ancient design produced by a line of small running stitches made parallel to the edge of a fold. This results in a line composed of two rows of resist marks, one row on each side of the fold. The pattern is similar to a form of goldwork couching called *ori nui* by the Japanese.

You will need:

Needles
Strong polyester thread
Scissors
Water soluble pen

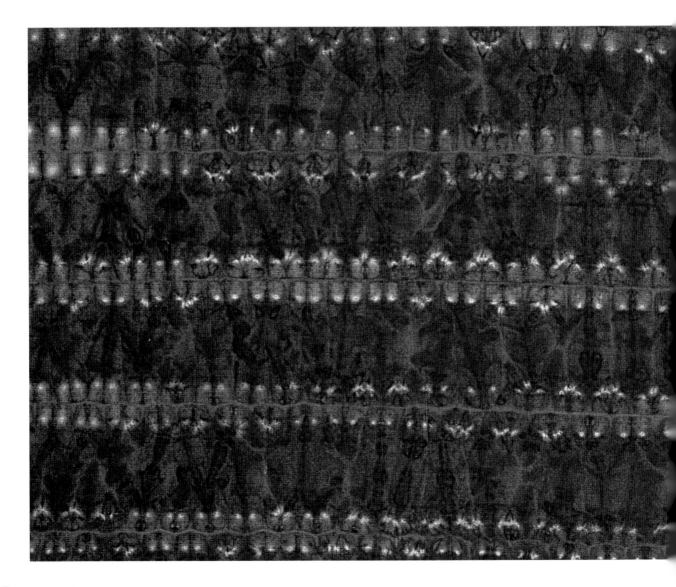

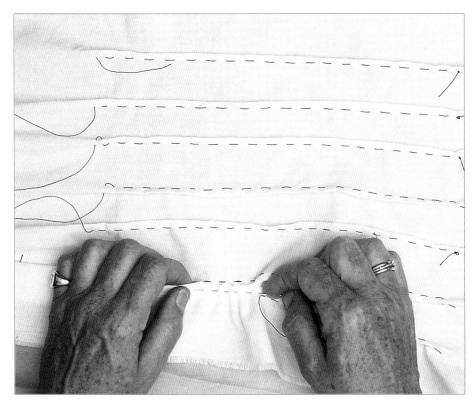

Note
Vary the depth of the fold or the length of the stitches, or work within a design.

1. Draw lines on the fabric with a water soluble pen. Pinch the fabric with your fingers along the lines of the design marked on the fabric. Make a single row of running stitches with a securely knotted continuous thread, close to the edge of this pinched up fold. Continue to pinch up as the stitching progresses.

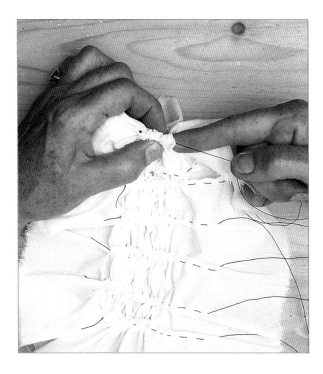

2. When the stitching is completed, draw the threads up as tightly as possible, then knot them off. The fabric is now ready to dye.

Karamatsu – Japanese larch

Concentric half-circles stitched on a fold produce dark, radiating lines within the design, which in Japanese culture represent the larch tree. The half-circles are traditionally stitched in staggered rows. Finish all your stitching before pulling the threads up very tight.

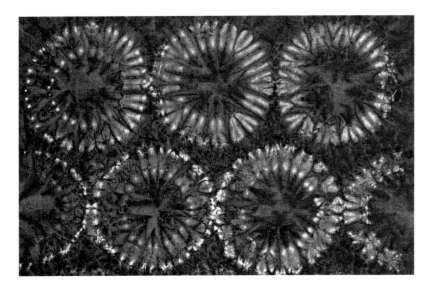

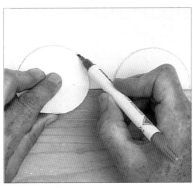

1. Use a water soluble pen and a card template to mark concentric half circles on a fold of fabric. For this design, the half circles are in staggered rows.

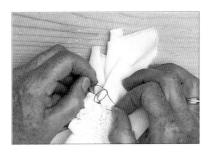

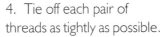

2. Make a single row of running stitch with a securely knotted, continuous thread. Stitch each row of half circles, through the two layers of fabric on the fold. At the end of the row, turn the fabric round and work another row of stitches inside the first row, finishing back on the knotted side.

4. Tie off each pair of threads as tightly as possible.

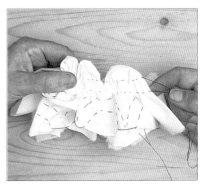

3. When all the stitching is completed, taking each pair of threads in your right hand, gather the fabric on the threads with your left hand. Work along the fabric in the same way, then cut the threads to a manageable length.

Note

Stitched rectangles produce a square pattern; squares produce a rectangular pattern; and V-shapes produce a diamond pattern.

Maki nui – chevron stripes

Over-stitch is used for this technique, instead of the usual running stitch. The stitch is made with a circular motion over a fold in the fabric, producing V-shaped horizontal patterns like chevrons.

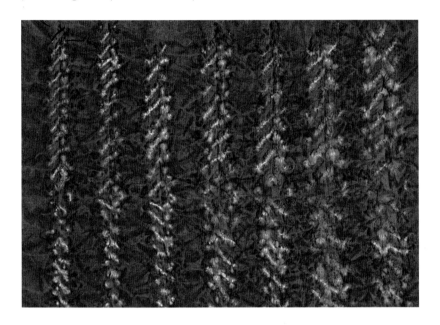

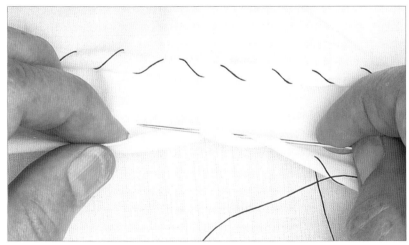

1. Hold the fabric on the fold. Stitch with a circular motion of the needle, inserting the needle at the back of the fold. Bring the point of the needle over the edge of the fold and insert it again from the back. Do not draw the thread up with each stitch; allow the fabric to gather on the needle. As stitching progresses, push the gathered fabric over the eye of the needle and on to the thread.

Note

You can reverse the circular motion of the needle or vary the size or density of the stitches to create different patterns.

2. After the stitching is finished, draw the thread up as tightly as possible and knot off. Then the fabric is ready for dyeing.

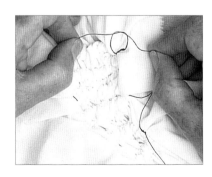

BOMAKI – POLE WRAPPING

The term *bomaki* literally means 'pole wound' and is used in shibori to describe any process in which a pole is used as a core to protect one side of the fabric from the dye. Fabric is wrapped around a pole in a variety of ways, then a thread is wound over it and the fabric is pushed up tightly before dyeing.

 The traditional Japanese process is not easy to produce on one's own, but by using different sizes of plastic drain pipe or plumber's pipe, and various thicknesses of thread, wonderful effects can be achieved. In the example shown below, the fabric is folded before being bound to the pole. This is my own variation of bomaki.

You will need:

Smooth plastic drain pipe
Strong thread or string
Masking tape
Clothes pegs
Cotton fabric, 80 x 38cm
(31½ x 15in)

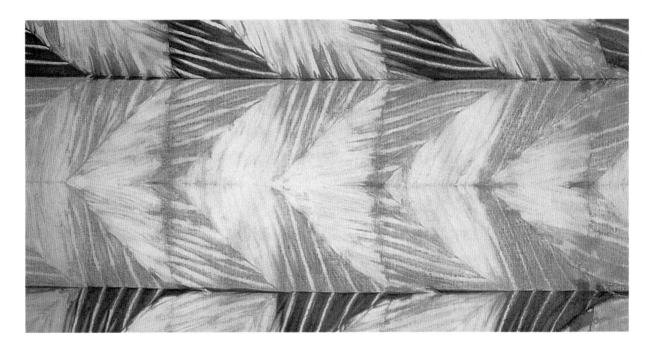

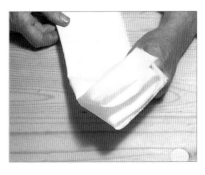

1. Take a piece of fabric and fold it lengthwise into a concertina shape as shown.

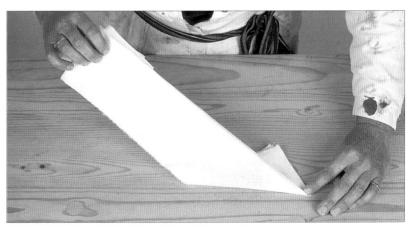

2. Lay the folded length of fabric down and fold it diagonally back on itself as shown.

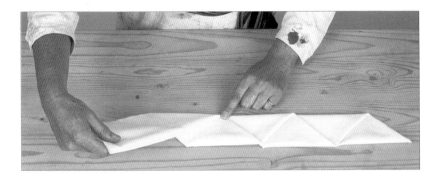

3. Fold the strip back in the opposite direction, and continue folding in the same way to produce the zigzag effect shown.

4. Peg the folds in place.

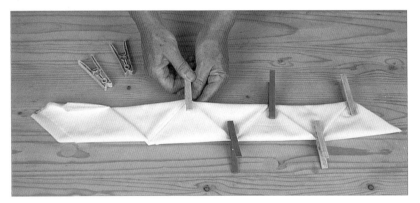

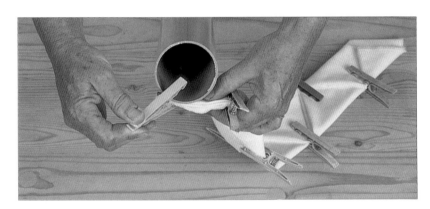

5. Peg the end of the folded fabric to the end of your length of drain pipe.

6. Wrap the fabric around the drain pipe, taking off the pegs as you go. Keep the fabric wrapped tightly around the pole.

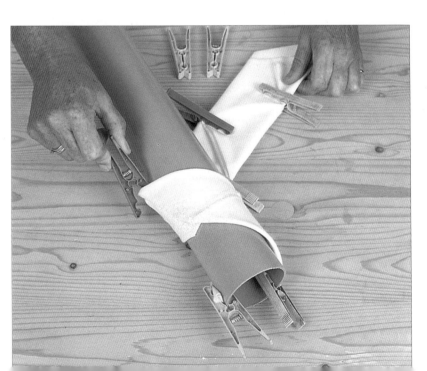

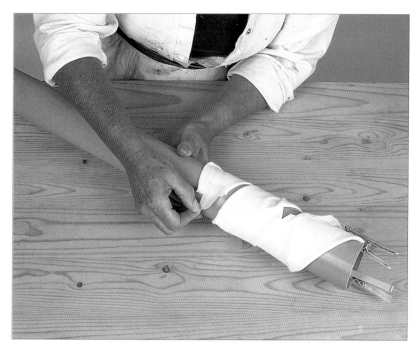

7. When all the fabric is wound round the drain pipe, fasten the end with masking tape.

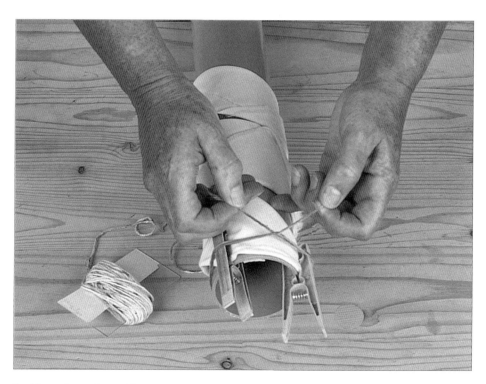

8. Knot the string with a clove hitch at the top. Take off the pegs. Holding the pole in your right hand and the string in your left hand, start turning the pole clockwise.

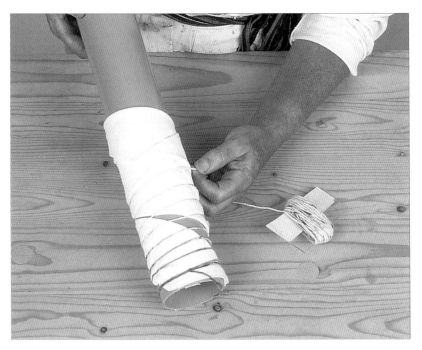

9. Turn the pole and wind the string around it. Hold the string on the left side a little way from the pole and continue turning. You need to get the tension of the string just right: too much and you will not be able to push the bound fabric up the pole later; too little and the fabric will not be held tightly enough. There is no right way. Just experiment to find a way to suit your own method of working. The closer the string, the finer the folds and the more intricate the pattern. Wrap to the end and take off the masking tape.

10. Tie off the end of the string and begin pushing the tied fabric down the pole towards your starting point.

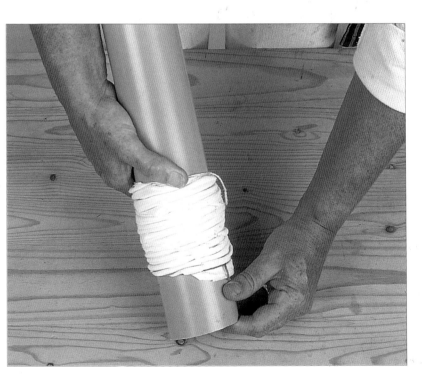

11. Compress the fabric as much as you can, exerting pressure on the fabric itself rather than on the string. Wet the pole-wrapped fabric thoroughly, and you are then ready to dip it in the indigo vat.

KATANO

Named after the Japanese batik artist Motohito Katano, this is an easy way of making beautiful fabrics. The fabric is folded and sandwiched between two layers of polyester, the width of the folded fabric. The polyester acts as a resist, and stitching through all layers defines the pattern by controlling the dye penetration, resulting in a wonderful ghosting of colour across the fabric. The stitching was traditionally done by hand, but using a sewing machine is quicker and gives a slightly different feel to the finished design.

You will need:

White silk velvet
Polyester fabric cover
Pins, needle and strong thread
Sewing machine
Water soluble pen

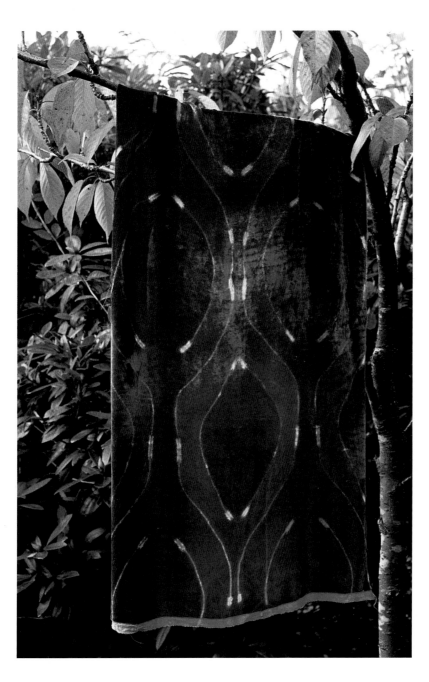

The finished design. The dyed fabric is used in the cushion project on page 90.

1. Fold the silk velvet into concertina pleats. Cut the polyester cover fabric to double the width of the folded fabric and fold the cover fabric in two. Place the cover on either side of the pleated fabric, hold it in place with pins, and tack. Mark the stitch pattern on one side of the polyester using water the soluble pen.

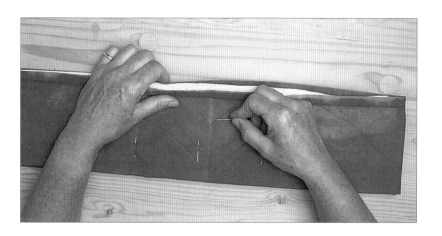

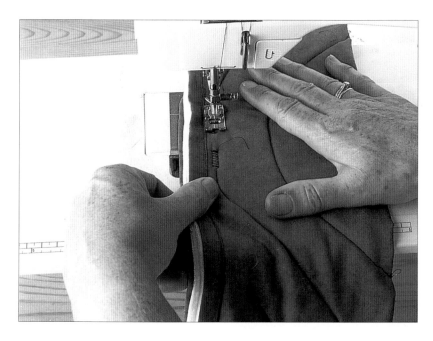

2. Use your sewing machine to stitch through the pleated fabric and polyester cover, following the marked pattern. If the sandwiched fabric turns out to be too thick to stitch by machine, hand stitch the pattern, piercing the fabric with right-angled stitches.

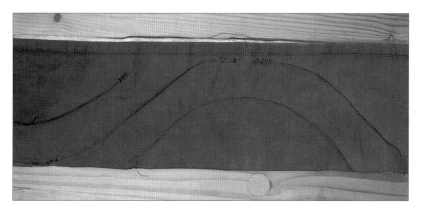

3. When you have finished stitching, remember to soak the fabric well before dipping it in the vat. After the dyeing process, remove the stitches carefully, air dry the fabric and wash it. Wash the polyester cover and keep it to use again.

PASTE RESIST

The Yoruba people of West Africa are famous for using paste resist to produce *adire-eleko*, cloths with intricate and beautiful patterns. The paste ingredients vary from place to place but basically consist of flour and water.

There are many variations on the technique shown below. You can apply paste through a stencil, or print with it using sponges, brushes, potato cuts or wood blocks. You can also under-dye using fibre-reactive dyes, then apply paste and finally dye with indigo.

You will need:

Heat-proof glass bowl

Plastic jug

Stainless steel container

Glass or metal stirrer

Bottle with fine nozzle, brush or sponge brush

1 tablespoon of plain white flour

1 tablespoon of rice flour

½ tablespoon powdered laundry starch

Water

Natural fabric

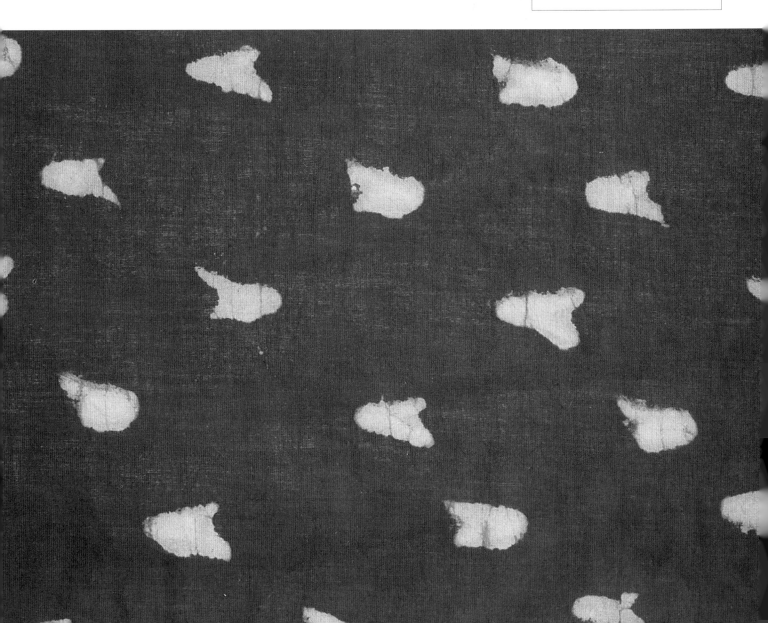

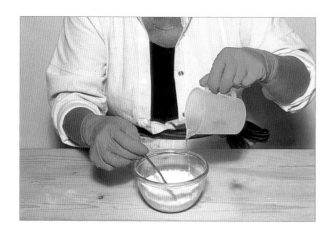

1. In a heat-proof glass bowl, mix the dry ingredients with a little cold water to make a smooth paste.

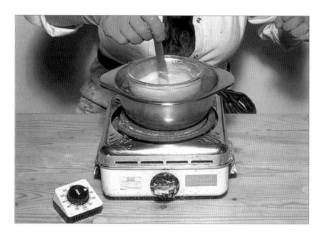

2. Place the heat-proof glass bowl inside a stainless steel container with a little hot water in it, to create a double boiler. Heat the paste for fifteen minutes, stirring all the time.

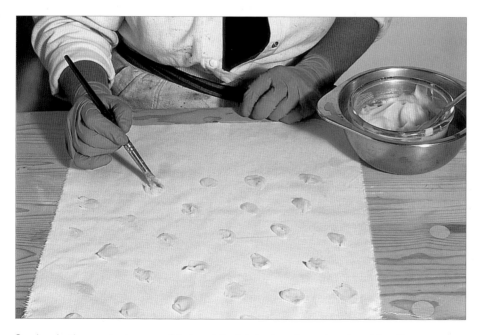

3. Apply the paste to your fabric while it is hot, using a bottle with a fine nozzle, a brush or a sponge brush. For more intricate patterns, you can use a stencil or a wooden printing block.

Note

Allow the paste to dry, then dip the fabric into the vat very carefully to avoid removing the resist. After dyeing and drying, scrape as much paste as possible from the fabric, so that it does not go down the drain when you wash the piece.

METHODS OF DYEING

Indigo, either natural or synthetic, is insoluble. To make it soluble so that it yields up its wonderful colour, the indigo must undergo reduction. Reduction is a process of extracting oxygen from the dye bath, making the indigo soluble in the form of a blueish bronze 'flower' on top of a brackish yellow vat streaked with blue. The fabric is dipped into the vat where this reduction process is occurring, and then hung in the air, at which point the reverse process, oxidation, occurs. The dyed fabric turns from yellow-green to indigo blue as the colour bonds to the fibres. Indigo dyeing is in essence this process of dipping (applying the colour) and air drying (fixing the colour). Fabrics freshly dyed with indigo tend to rub off on other fabrics, and indigo dyed threads will leave a mark on fabric if you need to unpick stitching. For this reason, good washing is necessary after dyeing, and treatment with vinegar can help to reduce cross-staining.

An indigo vat, like a yeast bread mix proving before baking, is a living, working reaction that gives off a small amount of gas. This continuing reaction means that the vat changes with time and use. The condition of the vat can be judged by the appearance of the indigo flower and the colour of the bath liquid. You will soon learn how to judge when reduction has occurred and the vat is ready for dyeing.

There are three ways of bringing about the necessary reduction: chemical fermentation using a zinc lime vat (page 46), chemical reduction using a hydrosulphite vat (page 58), and natural fermentation, using a bio vat (page 65) or even a urine vat (page 66)!

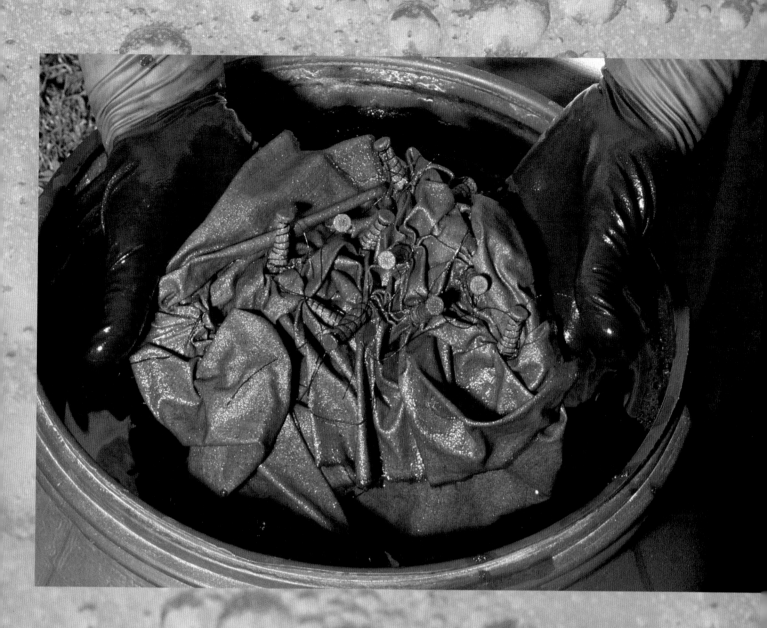

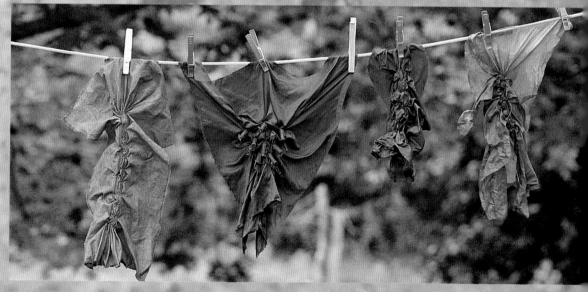

THE ZINC LIME VAT

Zinc metal dust is used as the reducing agent in this recipe, and lime (calcium hydroxide) is the alkaline agent. This vat takes twenty-four to thirty-six hours to ferment, but once working, can be maintained for several days at a time. If the vat is left to revert to insoluble through lack of maintenance, it can be 'sharpened' at any time and reused (see pages 56 –57). In fact, the vat I use is ten years old! I like the vagaries of this fermentation vat, the routine of the dyeing process, and most of all the wondrous blue it yields.

The zinc lime vat is prepared in two parts: a basic bath and a stock solution. The basic bath is a volume of water containing lime (calcium hydroxide) and zinc metal dust. The stock solution is indigo powder dissolved in methanol (methylated spirits), added to a small amount of hot water containing lime and zinc metal dust. The stock solution is then added to the basic bath. This new vat must stand for at least six or seven hours before it can be used. The indigo in the following recipe is sufficient to dye approximately 2.3kg (5lbs) of fabric. A larger vat can be prepared by multiplying all the ingredients proportionally and using a larger container. When the indigo is exhausted in the vat and sharpening no longer works, a new stock solution of the dye can be made up and added to the original basic bath (see page 57).

(see pages 56 –57)

(see page 57)

MAKING THE BASIC BATH

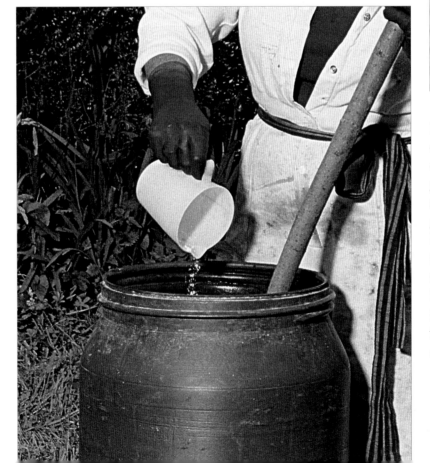

You will need:

Equipment

25 litre (5½ gallon) plastic container with an airtight lid

Stainless steel or enamel container with a lid or plastic food wrap to cover

Spoon

Scales

Thermometer

Heat-proof glass measuring jug

Plastic measuring jugs

Strong, smooth stick and glass rod for stirring

Protective clothing, rubber gloves and safety spectacles

You will need:

Basic bath ingredients

20 litres (4½ gallons) of water

20g (¾oz) calcium hydroxide

6g (¼oz) zinc metal dust

In a well-ventilated room or outside, fill your large plastic container with 20 litres (4½ gallons) of warm water. Wearing a particle face mask and rubber gloves, add the calcium hydroxide and zinc to make the basic bath and stir with the long stick to disperse the lime. Remove 1 litre (2.2 pints) of liquid from the basic bath and set this aside for rinsing the pot containing the stock solution.

MAKING THE STOCK SOLUTION

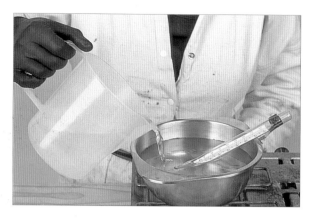

1. Pour the warm water into the stainless steel or enamel container, and place on a very low heat – just enough to keep the water at about 60°C (140°F).

You will need:

Stock solution ingredients

2 litres (3½ pints) of warm water

20g (¾oz) synthetic indigo microperle

100ml (3½ fl oz) methanol

40g (1½oz) calcium hydroxide

12g (½oz) zinc metal dust

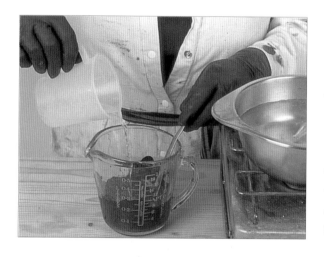

2. Weigh the indigo and place it in the heat-proof glass measuring jug. Add the methanol, a very small amount at a time, stirring all the while to make sure you have a thoroughly smooth paste throughout the operation. This takes some time.

3. Holding it by the handle, lower the jug into the container of warm water, tilting it so that the water can get into the jug and most of the contents of the jug can smoothly slip out into the water. Gently stir the indigo paste and the water together, working slowly and carefully. Do not empty out the dregs of indigo remaining in the bottom of the jug, as you will use this 'dirty' for the next step.

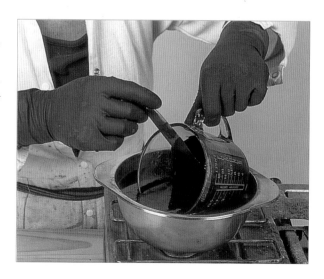

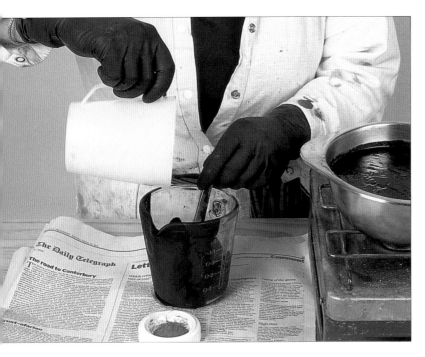

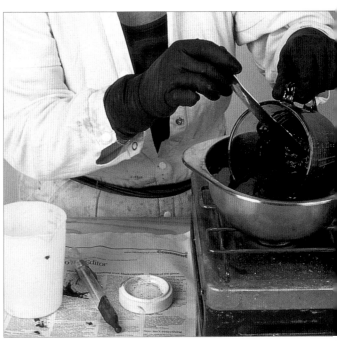

4. Mix the weighed calcium hydroxide and zinc in the 'dirty' jug with the dregs of the indigo, to form a smooth paste.

5. Add this paste to the indigo solution by lowering the jug into the liquid in the same way as before, blending all the paste with the liquid.

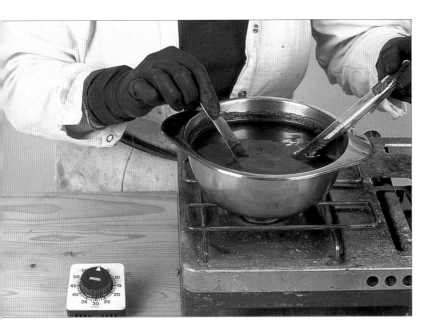

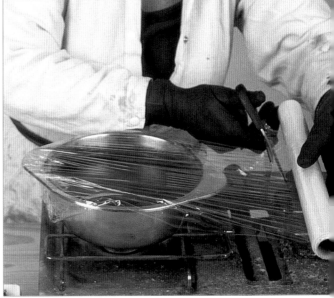

6. While stirring the stock solution with a stick or glass rod, turn up the heat a little. The temperature of the stock solution must not exceed 60°C (140°F) at any time – use the thermometer and adjust the heat accordingly. Continue stirring for about five minutes.

7. The stock solution will change to a greenish colour and a metallic, bronzy film with dark purple bubbles will begin to form on the surface. Turn off the heat. Cover the container in food wrap and allow the stock solution to rest undisturbed for three to five hours.

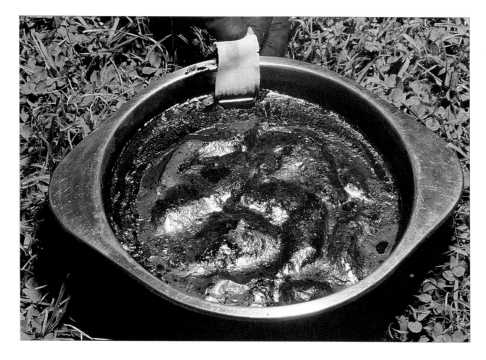

8. After resting, the stock solution should look like this, with a bronzy film on top and purple bubbles. To be sure that the indigo has properly reduced, test the solution by dipping a small strip of cotton fabric into it for a few seconds. The fabric when removed should be a yellowish colour that turns green, then indigo blue when exposed to the air.

COMBINING THE STOCK SOLUTION WITH THE BASIC BATH

1. Slowly and gently lower the bowl containing the stock solution into the basic bath so that the solution slips out into the surrounding liquid.

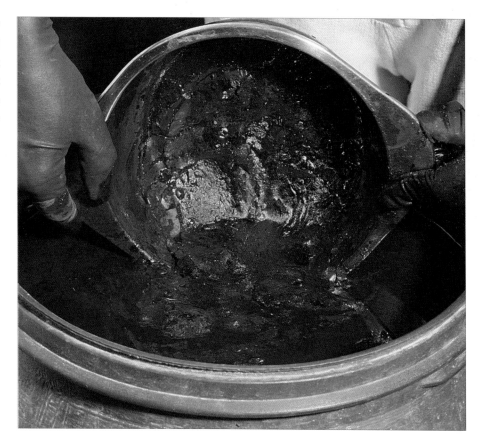

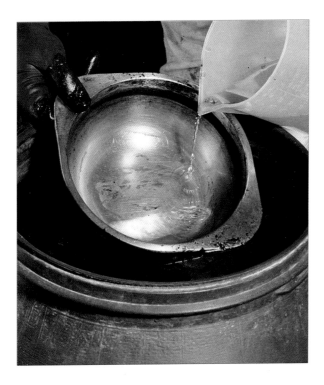

2. Rinse all the sediment out of the stock solution bowl and into the vat with the liquid you set aside when making the basic bath.

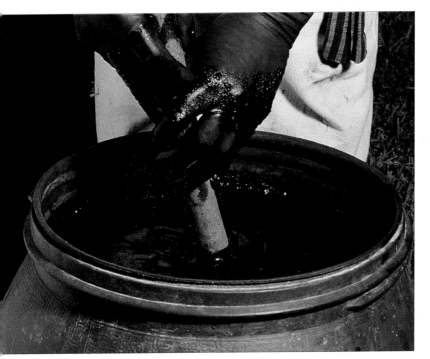

3. Stir the vat clockwise with the wooden stick, keeping the end of the stick on the bottom of the vat. Stir vigorously for a few minutes until the liquid forms a whirlpool. Stop stirring and hold the stick still, with the end still on the bottom of the vat, in the centre.

4. When you stop stirring, bubbles and sediment should gather in the middle of the vat, around the stick, forming the indigo 'flower'. Remove the stick and cover the vat. Let it stand for at least six hours or overnight before dyeing.

DYEING FABRIC

The zinc lime vat is not caustic, although it is alkaline, but you should always wear rubber gloves to protect your hands while dyeing, as well as comfortable protective clothing and safety spectacles to protect your eyes from the chemicals.

After pre-washing and before dyeing, cellulose fibres should be soaked in cold water for about ten minutes. Protein fibres should be soaked in warm water for about twenty minutes. Shibori shaped fabric should be moved around in the water to ensure that it is thoroughly wetted.

1. An indigo vat in good condition always has an accumulation of bubbles on the surface. This is called the 'indigo flower' and is made up of dark, bronze bubbles in the centre, surrounded by bubbles of a lighter blue.

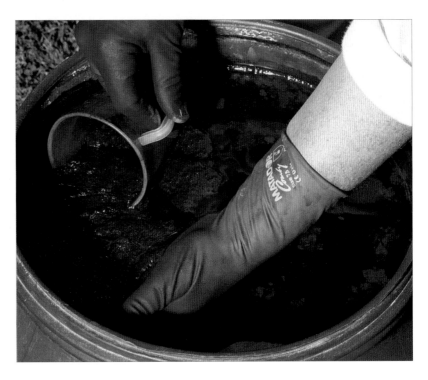

2. Before dyeing, skim off this flower with any other bubbles and save them in an ice cream carton or other plastic container. You will return them to the vat when the dyeing is finished.

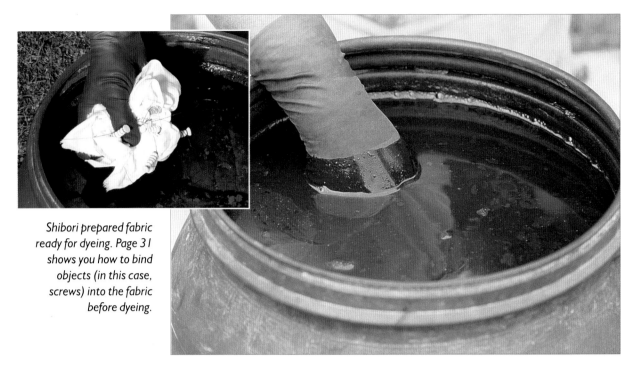

*Shibori prepared fabric
ready for dyeing. Page 31
shows you how to bind
objects (in this case,
screws) into the fabric
before dyeing.*

3. Slowly immerse the prepared, wetted out fabric in the dye bath. Shibori shaped fabric will have air trapped in it. Try to ease the fabric into the vat in such a way as to minimise the amount of trapped air that enters the liquid.

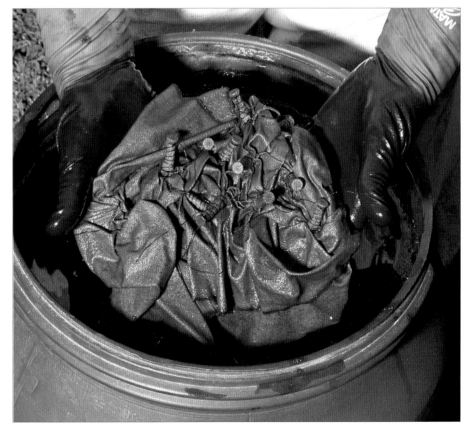

4. Hold the fabric just below the surface of the vat, moving it around gently and taking care not to disturb the zinc-lime sediment in the bottom of the vat. After three to ten minutes, remove the fabric and squeeze out the liquid into a plastic container. You can return this liquid to the vat after dyeing.

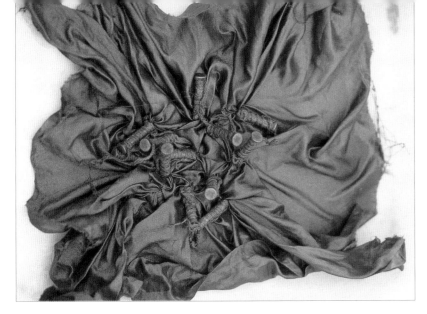

5. Place the dyed fabric on newspaper or in a plastic container and, to ensure oxidation of the indigo, carefully open out the folds and gathers to expose all the fabric to the air. If possible, work outside on a sunny day and watch the wonderful colour change that takes place in the fabric.

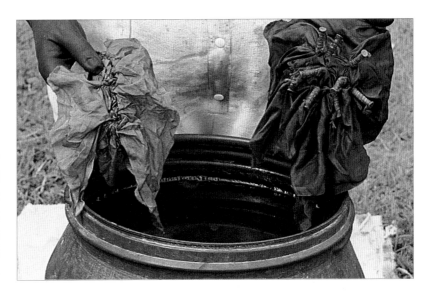

6. You can of course dye any number of prepared pieces of fabric in the same vat. If you want a darker shade of indigo, repeat the dip. To obtain the optimum colourfastness, the fabric should be dried before each dip.

Twisted, pole-wrapped silk ready for dipping in the vat...

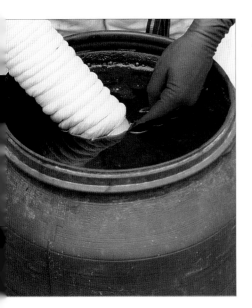

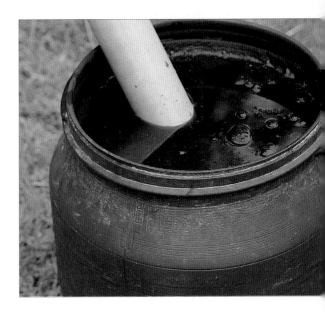

...and being dyed.

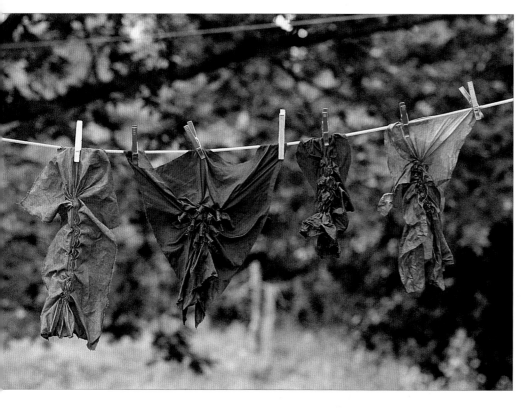

7. Hang the fabric out to dry when you are happy with the depth of colour. Remember that fabric looks much darker when wet. When it is dry, hang it in an airy place for anything from a few hours to a week before washing.

The pole-wrapped silk hanging out to dry.

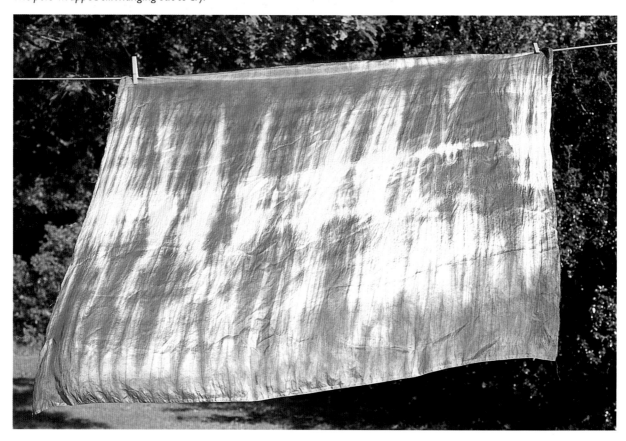

54

Note

The treatment of the fabric after dyeing depends on the method of fabric preparation you have used and the effect you want to achieve. If you want sharp pleats or defined textures, you will need to steam the fabric before removing the binding. See page 68 for the steaming method.

8. Remove any stitching and unfold, unwind or unclamp, depending on the method of fabric preparation.

9. Rinse repeatedly in fresh lots of cold water, until the water is clear. For silk and wool, add vinegar to the rinse to counteract the alkalinity of the vat, which harms protein fibres. A final rinse through in warm water and a little fabric conditioner will restore the fabric to its natural lustre.

This picture shows an alternative effect. The screws were left in during dyeing, drying, washing and re-drying. The fabric is shown here after it was steamed and the bindings were removed. No textured pattern is permanent on natural fabric, so this effect would not survive washing, but if you wanted to preserve it like this you could try padding and quilting.

MAINTAINING THE VAT

An indigo vat is a living, working reaction and changes with time and use. The condition of the vat can be judged by the appearance of the indigo flower and the colour of the bath liquid. The flower of a healthy vat is made up of dark, bronzy blue bubbles, thickest in the centre, surrounded by paler blue bubbles. The size of the flower varies but it should be about 15–20cm (6–8in) in diameter.

The colour of the vat when stirred will be a greenish yellow-brown. If it is a bright greenish yellow, the colour of English mustard, then it probably contains too much zinc. The colour of French mustard is about right.

When the vat is stirred and it is in good condition, blue streaks appear in the brownish mustard-coloured liquid. If there is an excess of zinc in the vat, it will adjust itself in a few days, but to be sure, add more calcium hydroxide (hydrated lime) to keep the chemicals in balance. Add the lime one teaspoon at a time. Do not sprinkle the powder, but drop a full teaspoonful into the liquid: the lime will stay together and float on the surface. If it is absorbed quickly, add more. When it floats without being dissolved into the liquid, the vat contains enough lime.

A darkening and change in the colour of the vat when stirred (it will turn green with pale blue or clear bubbles), and a decrease in the size of the flower are indications that the indigo in the vat is reverting to its insoluble state, and zinc is needed to bring it back to its reduced, or soluble state. This is called 'sharpening' the vat.

Pale blue bubbles in a vat that needs sharpening.

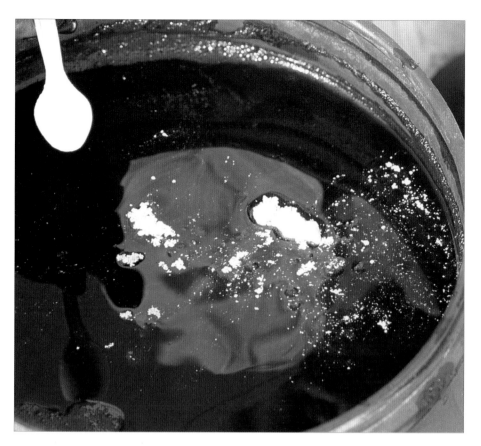

Double check the need to add zinc by inserting a white plastic cup below the surface of the vat. If the liquid is light blue or colourless instead of being a greenish yellow when seen against the white cup, sharpen it by adding 6g (¼oz) of zinc and some lime. The amount of lime depends on the condition of the vat. Add 1.5g (one teaspoon) at a time, dropping a full teaspoon in rather than sprinkling the powder on the surface. The vat may need as much as 20g (¾oz) of lime. When there is enough lime in the vat, it will float on the surface as shown above. Stir the vat thoroughly and let it stand for six hours. Check the vat by testing with a strip of cotton, which should turn blue when exposed to the air. If the reduction has not taken place, repeat the sharpening process.

When the indigo is exhausted, the liquid will be clear, with no indigo particles floating in it, and sharpening will have no effect. To replenish the vat, remove 2 litres (4½ pints) of the basic bath and prepare a new stock solution using this liquid. Add this new stock solution to the old basic bath and stir.

The liquid in an exhausted vat, which needs replenishing with a new stock solution.

THE HYDROSULPHITE VAT

Sodium hydrosulphite, sold commercially as Colour Run Remover, or sodium dithionite are the chemicals used as the reducing agent in this group of recipes. Sodium hydroxide (caustic soda) and ammonia are the chemicals used to create a strong alkaline vat. The reducing agent is combined with the alkaline vat, and the chemical reaction turns the indigo from insoluble to soluble, releasing the colour.

 This method of dyeing is quick to prepare and easy to use. However, it is caustic, it has an unpleasant smell, and it cannot be maintained for any length of time.

 The indigo in the following recipe is sufficient to dye approximately 300g (10½ oz) of fibre. A larger vat can be prepared by multiplying all the ingredients proportionally and using a larger container.

 When the indigo is exhausted, a new indigo solution can be added to the original basic bath.

> **You will need:**
>
> Equipment
> Stainless steel bucket
> Heat-proof glass bowl
> Thermometer
> Glass or wooden
> stirring stick
> Plastic measuring jugs
> Scales
> Protective clothing, rubber
> gloves and safety spectacles

MAKING THE INDIGO SOLUTION

The hydrosulphite vat is made up of an indigo solution which is later combined with a basic bath.

> **You will need:**
>
> **Indigo solution ingredients**
>
> 50g (1¾ oz) washing soda
> 300ml (10½ fl oz) boiling water
> and 30ml (1 fl oz) warm water
> 10g (½ oz) natural or 5g (¼ oz)
> synthetic indigo microperle

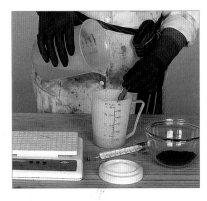

1. Dissolve 50g (1¾ oz) of washing soda in 300ml (10½ fl oz) of boiling water, stirring all the time.

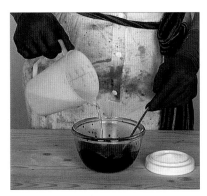

2. Place the indigo in a heat-proof glass bowl and add 30ml (1 fl oz) of warm water a little at a time, stirring all the time to make a smooth paste. Gradually add the washing soda solution in the same way, stirring slowly.

COMBINING THE INDIGO SOLUTION WITH THE BASIC BATH

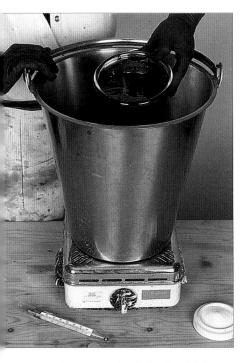

You will need:

4 litres (7 pints) of water
25g (1oz) sodium hydrosulphite

1. Prepare a basic bath of 4 litres (7 pints) of water in a stainless steel bucket, heated to 45–55°C (113–131°F). Do not let the temperature exceed 60°C (140°F). Lower the indigo solution into the water, tilting the bowl so that water enters it and the contents slip smoothly out into the water. Stir gently, washing out the bowl and blending all the paste with the water.

2. Sprinkle 25g (1oz) of sodium hydrosulphite over the surface of the vat and let it stand at a constant heat of 45–55°C (113–131°F) for thirty to sixty minutes. Keep the vat covered whenever possible, as this maintains temperature and reduces oxidisation.

3. After an hour, the solution should be a yellow-green brackish colour with a bloom of bronzy bubbles on the surface, known as the flower. If the vat appears pale blue, sprinkle on a little more sodium hydrosulphite and leave to stand for a further ten to fifteen minutes.

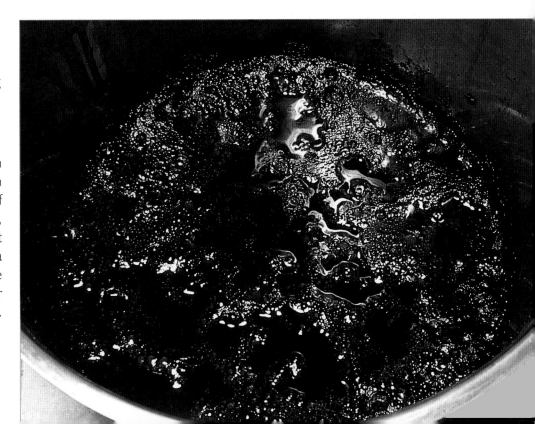

DYEING FABRIC

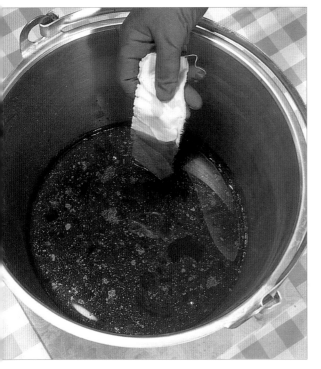

You will need:

Hydrosulphite vat

Fabric for dyeing and strip of cotton for testing

Plastic jugs and containers

Pegs for line drying

Protective clothing, rubber gloves and safety spectacles

1. Always protect your surfaces when working indoors. To be sure that the indigo has properly reduced, test the solution by dipping a small strip of cotton into it for a few seconds. The fabric should come out a yellowish colour that turns green and then indigo blue when exposed to the air.

2. Skim off the flower of bubbles from the surface of the vat before dyeing.

3. If you are dyeing protein fibres, keep the vat at 50°C (122°F). Here a machine-stitched mokume silk scarf, prepared on page 29, is being dipped into the vat. Lower the fabric into the vat and gently move it around for five to ten minutes.

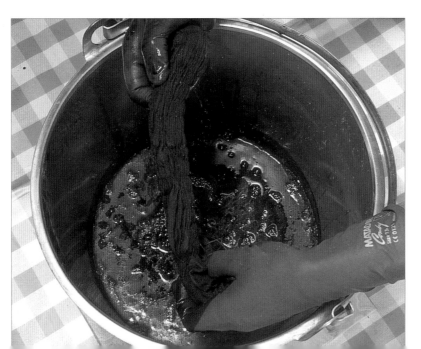

4. Lift the fabric out and let it drain into a container, then hang it on the line, opening out the folds to allow oxidation. Air it for about half an hour and re-dip it for three to five minutes if you want a darker shade.

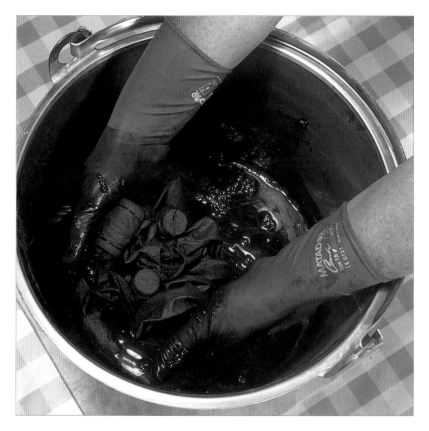

5. Here, fabric bound with corks is being dipped in the same single use hydrosulphite vat.

Note

The hydrosulphite vat needs constant checking to make sure that it stays active. With repeated dipping it will become impoverished and the colour will change from yellow-green to blue. Add a little more sodium hydrosulphite to prolong its life. When you have finished dyeing, exhaust the vat by putting an old cellulose cloth into it overnight, then aerate it by whisking it well. You can then dispose of it down a toilet.

The machine-gathered mokume silk scarf after dyeing, with the stitching only partially unpicked.

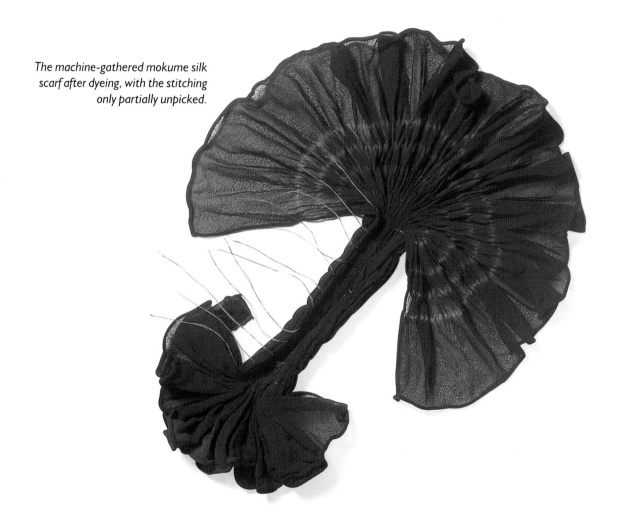

RECIPES FOR PROTEIN AND CELLULOSE FIBRES

I dye both protein and cellulose fibres in my zinc lime vat, observing the different dipping times for each type of fibre. However, because of their different structures, protein and cellulose fibres absorb dye at different rates and under

Note

For information on solutions see page 16.

PROTEIN FIBRES

Basic bath ingredients

10 litres (2.2 gallons) water at 50°C (122°F)

25ml (1 fl oz) calcium hydroxide 10% solution

2–3g (0.1oz or ½ teaspoon) powdered gelatin

60ml (2 fl oz) ammonia 25% solution

5g (0.2oz or 1 teaspoon) sodium hydrosulphite

100–200g (3½–7oz) salt for darker shades

Basic bath method

Pour 10 litres (2.2 gallons) of warm water into a stainless steel bucket. Keep the temperature at 50°C (122°F) throughout. Then add the ingredients in the order given and stir.

Stock solution ingredients

30g (1oz) synthetic indigo microperle

100ml (3½ fl oz) methanol

400ml (14 fl oz) warm water

50ml (1¾ fl oz or 3 tablespoons) sodium hydroxide 25% solution

30g (1 oz or 6 teaspoons) sodium hydrosulphite

200g salt

BOTH FIBRES

Equipment

Stainless steel bucket

Glass jar with lid

Thermometer

Glass or wooden stirring stick

Glass measuring jug

Plastic measuring jug

Scales or plastic measuring spoons

Double boiler

CELLULOSE FIBRES

Basic bath ingredients

10 litres (2.2 gallons) rainwater or softened water at 24°C (75°F)

25ml (1 fl oz) calcium hydroxide 10% solution

2ml (1/16 fl oz or ½ teaspoon) sodium hydroxide

3g (0.1oz ½ teaspoon) sodium hydrosulphite

200g (7oz) salt

Basic bath method

Pour 10 litres (2.2 gallons) of water into the bucket. The temperature should not exceed 20–24°C (70–75°F) throughout. Then add the ingredients in the order given and stir.

Stock solution ingredients

30g (1oz) synthetic indigo microperle

100ml (3½ fl oz) methanol

400ml (14 fl oz) warm water

50ml (1¾ fl oz or 3 tablespoons) sodium hydroxide 25% solution

30g (1 oz or 6 teaspoons) sodium hydrosulphite

different chemical conditions. Cellulose fibres take up far less of the oxidised indigo than protein fibres such as wool, and repeated dippings will not harm cellulose fibres as they would protein fibres. For these reasons, you may want to use versions of the hydrosulphite recipe that are specific to the type of fibre you are dyeing. The following recipes are for anyone wishing to improve the dye take-up of cotton, or to dye using batik or paste resist, or to dye wool in a lower pH vat to avoid harming the fibres. The amounts in each recipe will dye approximately 300g (10½oz) of fibre.

Note

When dyeing protein fibres, a pH of 8.5 is ideal, so keep checking the vat using a pH meter or litmus paper.

Making the stock solution

Place the indigo in a jar, add the methanol a very little at a time, stirring all the time to make a smooth paste. Then stir in the 400ml (14 fl oz) of warm water, which should be 45–55°C (113–131°F). Add the other ingredients in the order given and stir gently. Cover with the lid and place jar in the double boiler at 50°C (122°F) for one hour if using natural indigo, fifteen minutes for synthetic indigo. The solution will now be a yellow-green brackish colour. To be sure that the indigo has properly reduced, test the stock solution with a strip of cotton as shown in step 1, page 60. This stock solution can be kept in a well-marked, tightly sealed container in a safe place for some time. When you use some, add glass beads to top up the liquid level, as this keeps the air in the container to a minimum.

Combining the stock solution with the basic bath

To prepare a protein vat for a deep blue-black tone, add 150ml (5¼ fl oz) of stock solution. For a deep blue, add 50ml (1¾ fl oz or 3 tablespoons). For a medium blue, add 15ml (½ fl oz or 3 teaspoons). For light blue, add 5ml (0.2 fl oz or 1 teaspoon).

To prepare a cellulose vat for deep blue, add 250ml (8 fl oz) of stock solution. For medium blue add 50ml (1¾ fl oz or 3 teaspoons). For a light shade add 10ml (0.4 fl oz or 2 teaspoons).

Add the measured stock solution to the cellulose or protein basic bath, depending on the fibres you are dyeing. Stir gently, then cover the vat and keep it at a constant temperature of 45–55°C (113–131°F) for a protein vat; 20–24°C (70–75°F) for a cellulose vat, for thirty to sixty minutes. Skim off the flower of bronzy blue bubbles before dyeing.

Dyeing fibres

Gently lower the damp fibres into the vat. Move the fibres around in the liquid for five to fifteen minutes for a protein vat and five to ten minutes for a cellulose vat. Lift out and drain off excess liquid in the usual way, then hang on the line. Air dry protein fibres for about ten minutes and re-dip if necessary. If the colour is still not dark enough, it is better to add more stock solution to the vat rather than keep re-dipping, which puts the fibres under strain. Air dry cellulose fibres for about thirty minutes and re-dip for one minute at a time, up to a maximum of four times. Then wash, adding a cupful of vinegar to the rinse to counteract the alkalinity of the vat.

With constant dipping, the vat will become impoverished and the colour will change to clear blue. Add more stock solution or sharpen by adding more basic bath ingredients.

DYEING YARN

When dyeing yarn, whether it is a protein fibre such as wool or silk or a cellulose fibre such as cotton, the hanks or skeins must be tied loosely in about three places to avoid tangling. Slowly immerse the wetted hank or skein into the vat, working it gently between your hands to be sure that all parts are evenly exposed to the indigo. See the dipping times for protein and cellulose fibres given on page 63. Gently lift the fibres out of the vat and squeeze out excess liquid into a plastic container. The liquid can be returned to the vat at the end of the dyeing session. Hang the hanks or skeins on the line, opening them out as much as possible to ensure oxidation of each length, and turning them to expose different areas to the air. Protein fibres such as wool or silk can be damaged if they are left in an alkaline solution for too long. To prevent this, after air drying for about an hour, rinse in cold water with a good cupful of vinegar, then wash in pure soap. Wash wool carefully or it will felt. Continue rinsing until the water is clear, then hang up to dry.

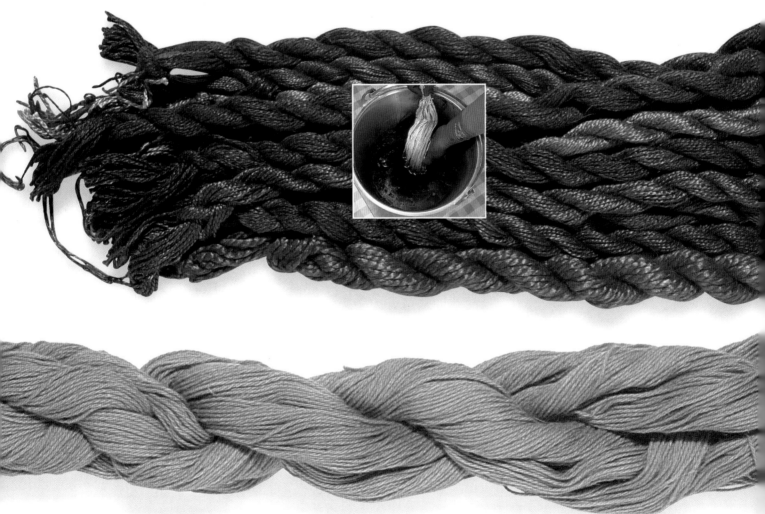

OTHER RECIPES

THE BIO VAT

The bio method, using bacterial or fermented indigo, has been a traditional way of dyeing for thousands of years. The Los Ojos Hand Weavers of New Mexico have enormous respect for the importance and wisdom of these traditional practices, and they have learned from them, as well as from modern science, in developing their own methods of indigo dyeing. They have passed the details of their bio vat on to me.

The bio method is a time-consuming but very pleasing way to dye fabric – you must keep reminding yourself that it is an ancient, traditional art and cannot be rushed.

The fermentation vat should be made outside or in a well-ventilated place, as the bacterial process and the natural ammonia it produces are a bit smelly. Plan well ahead as, depending on the temperature, the amount of food for the bacteria, the strain of bacteria used, the source of indigo and the water used, the vat can take between a week and a month to work. The amounts given are approximate, even arbitrary. Do not give up hope. If you add more or less, the vat will work slower or faster.

If you are patient, this environmentally friendly vat can be kept for years, adding more indigo and bacteria as necessary.

The vat works best at above 80°C (176°F). In summer, leaving it out in the sun should keep it warm enough, but in winter you may need to wrap it in an electric blanket or heat it with an aquarium heater.

This recipe uses biological septic tank starter to start the bacterial process. Some dyers use only the natural bacteria that is in the indigo as a starter, others add madder root or yeast, but this seems less effective in removing the oxygen from the vat than the septic tank starter. Simply leaving the vat exposed to the air will eventually start the bacterial process. By using ammonia, washing soda or calcium hydroxide, you can speed up the reduction.

Fill the vat with 45 litres (10 gallons) of warm water. Stir in the urea, sugar, bran and starter. Once opened, store the starter in a well-marked, safely sealed container in the refrigerator for future sharpening

You will need:

50 litre (11 gallon) plastic, stainless steel, ceramic or wooden container

Pestle and mortar

Stirring stick

Various plastic containers

2.2kg (5lb) urea

142g (5oz) oat, wheat or rice bran

340g (12oz) sugar, dates, raisins or any sweetener

Natural indigo

20g (¾oz) biological septic tank starter

45 litres (10 gallons) of warm water

pH paper or pH meter

Ammonia, washing soda, soda ash or calcium hydroxide

Vinegar

of the vat. Cover the vat, but not with an airtight lid. Try to keep a daily diary of the state of the vat and the development of fermentation.

The natural indigo can be added any time during the first week. Do not use synthetic indigo, as it does not work well with the bacterial process. The amount of indigo added depends on what shades of blue you wish to achieve. If you want dark shades, add 280g (10oz) of powdered indigo but if you want to start with lighter shades and slowly build up the depth of colour, start with 150g (5¼oz).

Check the vat daily: the liquid will slowly turn blue-green, then green and finally yellow-green. Test the vat: the pH should reach about 8–8.5 for dyeing wool and about 10.5–11 for cotton. When the vat is yellow-green, dip your fibres for about twenty minutes, air drying between dips. Do not use the vat for more than two hours at a time. When you have finished a dyeing session, return the drained liquid to the vat, stir well and replace the cover. Stir the vat daily when not in use. Feed a working vat once every week to ten days with half the original amount of urea, oat bran and sugar, gently stir and cover. If after a few days the vat has not reached pH 10.5, for cellulose fibres add ammonia 25% solution.

Sharpen the vat when the liquid reverts to clear by adding more of the basic bath ingredients and more indigo. This will allow the process to begin again.

Note

Remember that the pH scale is logarithmic, each step is ten times as strong as the previous one, so it takes a lot more alkali to go from 10 to 11 than to go from 9 to 10. pH 10 is ten times more alkaline than pH 9, but pH 11 is 100 times more alkaline than pH 9.

THE URINE VAT

The Elizabethans shipped barrel loads of urine to Ravenscar in Cumbria, soaked local slate in it, then burnt the stone in huge bonfires for eight months to make the alum needed by the ever-growing spinning, weaving and dyeing trade.

I have to admit that I have not found the need to make up this vat, as it sounds time-consuming and very smelly, but I have included a recipe for any dye-hards!

Save four litres (8.8 pints) of urine in a container with a well-fitting lid. Dissolve two teaspoons of synthetic indigo microperle in the liquid, put the lid on and keep it at a constant temperature of 50°C (122°F). Stir it daily, always replacing the lid. After about two weeks the indigo should have reduced to yellowish green, and the vat is ready for use. Wet the fabric to be dyed and put it gently in the liquid. Reseal the container and leave the fabric to soak for five to six days. Remove the fabric from the vat and allow it to air dry for thirty to sixty minutes, then return it to the vat. Repeat this process twice a day until you achieve the desired depth of colour. Air dry the fabric and wash it well, adding vinegar to the final rinse. Hand wash and dry it. The vat can be used until the colour is exhausted.

Photograph opposite: Carolyn Wilkins, South West Industrial Crops

DYEING WITH INDIGO EXTRACTED FROM THE *POLYGONUM TINCTORIUM* PLANT

Cut the plants down to two to three nodules; these will regrow. Strip the leaves from the stem, and cram them into a glass jar. Fill the jar with cold rainwater, then stand the jar in a large saucepan on a trivet, forming a double boiler. Over the course of an hour, bring the temperature up to 71°C (160°F), certainly no higher than 82°C (180°F), and turn off the heat. Strain the sherry-coloured liquid into a stainless steel bucket. Add half a handful of washing soda or a few drops of ammonia to make the vat alkaline (pH 7.5–8). The liquid will turn a dark green colour. Now aerate this liquid by pouring it back and forth between two containers for about ten minutes. The liquid will turn yellow with a blue froth. Reheat the liquid in a dye pan to a temperature of 50°C (120°F), then add half a teaspoon of sodium hydrosulphite per 4.5 litres (1 gallon), to reduce the solution. Maintain the heat for ten to fifteen minutes, then gently add your wetted, prepared fabric, moving it gently under the surface for twenty minutes.
Drain and dry as usual.

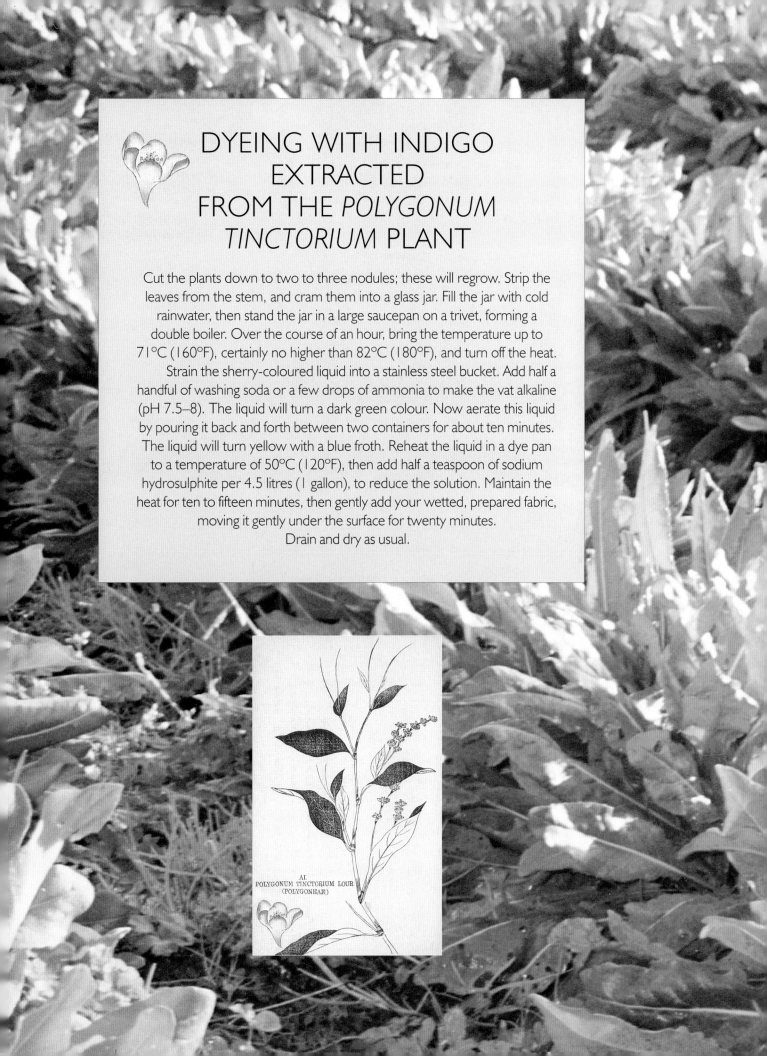

AI.
POLYGONUM TINCTORIUM LOUR.
(POLYGONEAE)

POST-DYEING TREATMENTS
STEAMING

For really sharp, pleated, textured fabric you will need to steam the fabric before taking out the threads or bound objects, in order to preserve the texture.

You will need:

Tissue paper
Kitchen foil
Clothes peg
Pressure cooker and trivet
Water

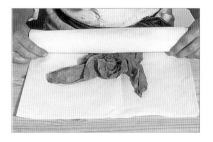

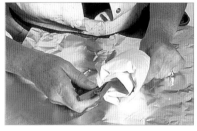

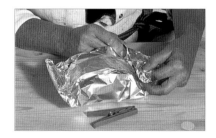

1. After dyeing, place the well washed, dried, manipulated fabric on a sheet of tissue paper or old newspaper, and roll it up like a sausage. Attach the end of the tissue paper to the fabric with a clothes peg.

2. Take the 'sausage' and roll it up the other way. Remove the clothes peg and place the wrapped parcel on a large sheet of kitchen foil.

3. Wrap the parcel in the foil. Put an upturned trivet in the bottom of a pressure cooker with sufficient water to reach halfway up the trivet. Place over a medium heat.

4. Place the parcel on the trivet, with the smooth side of the parcel uppermost and the closing folds downwards. Put on the lid and turn up the heat. Steam steadily on a medium heat for twenty to thirty minutes, turn off the heat, carefully take the hot bundle from the pressure cooker and remove the fabric from the wrapping. Allow the fabric to cool down before removing the threads.

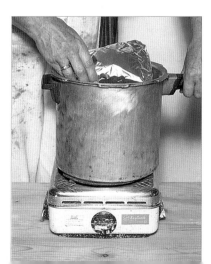

OVERDYEING AND DISCHARGING

Different effects can be achieved by underdyeing or overdyeing with indigo and fibre-reactive dyes. If you use a hydrosulphite indigo vat over fibre-reactive dye, the indigo vat will leach the colour from the dyed fabric.

Susan Bosence gives an excellent recipe for discharging indigo in her book *Hand and Block Printing*. If you paint or print potassium permanganate on to the finished mid-blue indigo dyed fabric, the paste will change the blue to a khaki colour. If you then soak the fabric in a solution of citric acid, this khaki colour is discharged to white, creating beautiful effects.

Fibre-reactive shibori dyed silk velvet scarves, overdyed with indigo.

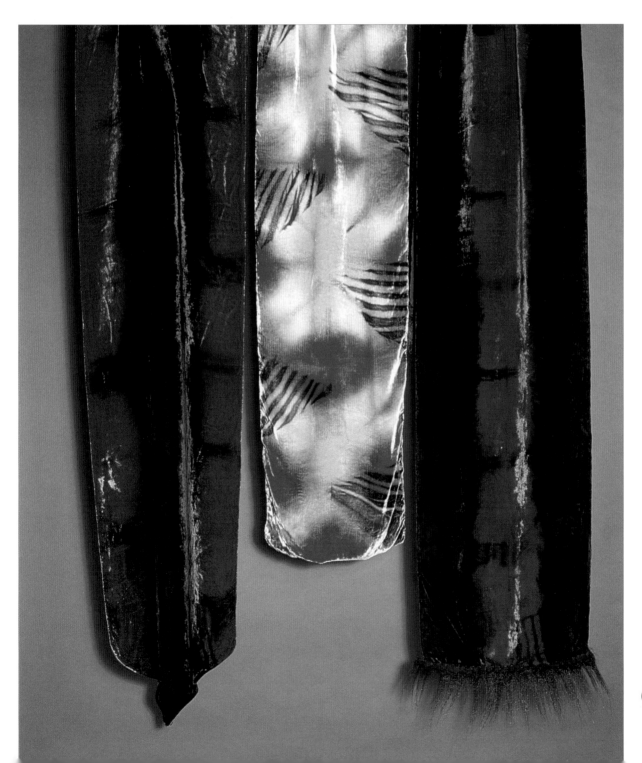

PROJECTS

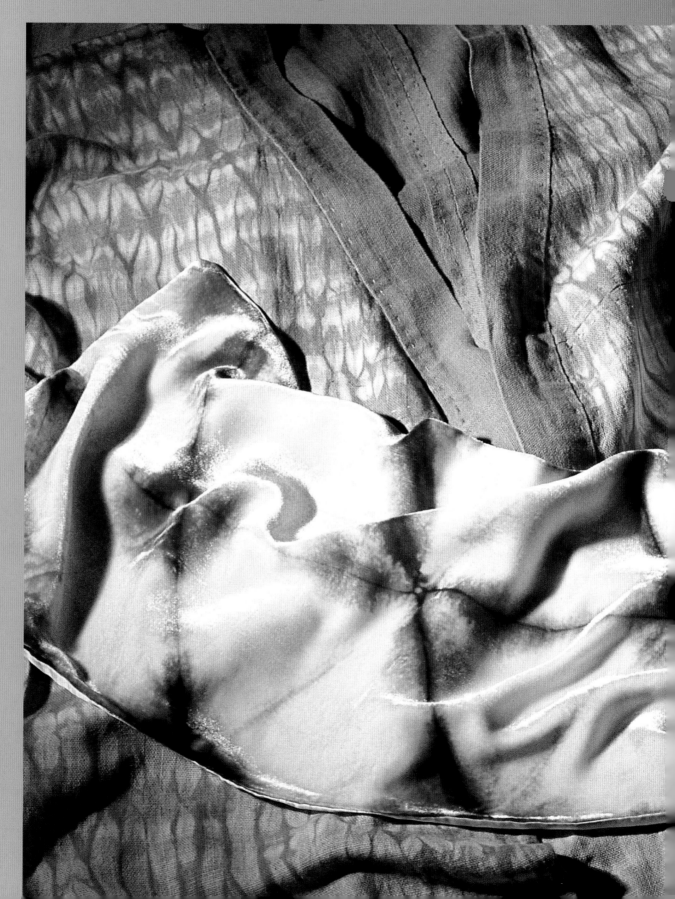

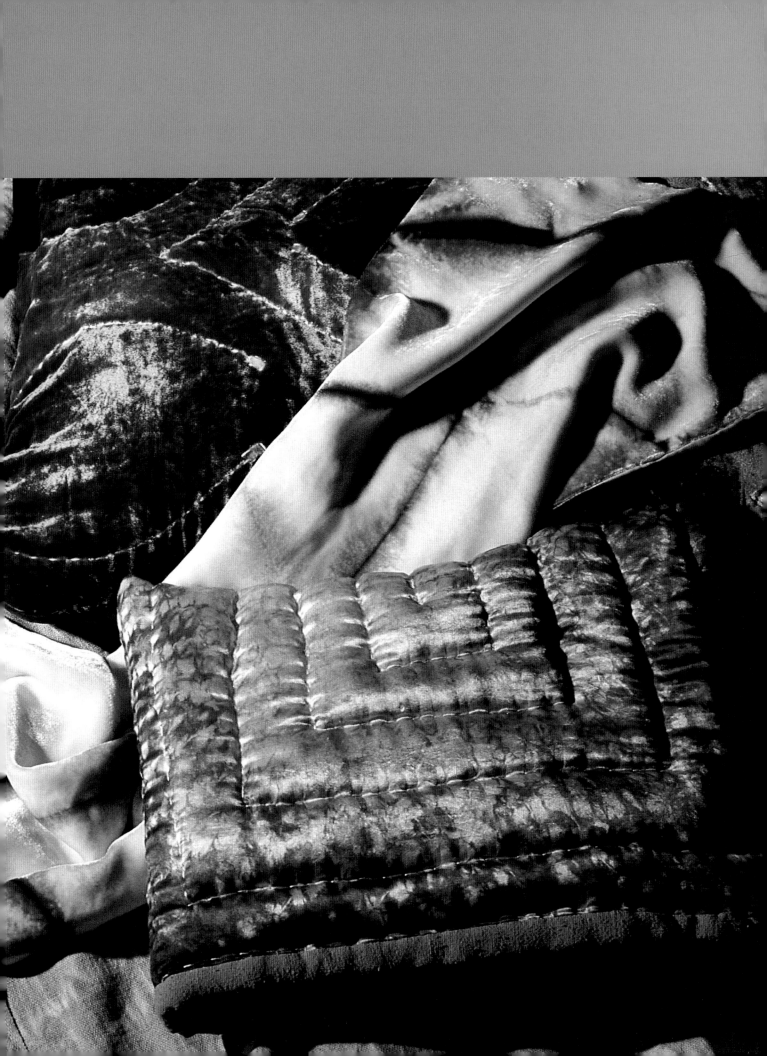

SILK VELVET SCARF

A scarf can be any length, depending on how you want to wear it. For this silk velvet scarf with a crepe de Chine lining, I used a 38 x 150cm (15 x 59in) piece of each fabric, allowing for 1cm seams. If you buy silk velvet that is 114cm (45in) wide, you can make three scarves from a 150cm (59in) length. I make up my scarves before dyeing, so that I end up with a double-sided scarf, and I do not need to worry about the lining matching the pattern on the velvet. Experiment with different fabrics: velvet, crepe de Chine, flat satin and georgette.

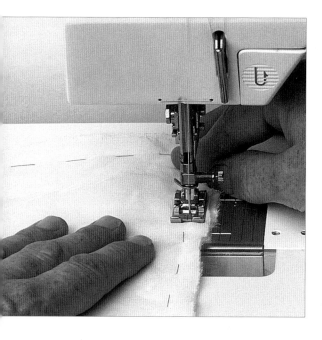

1. Pin then tack the silk velvet and the crepe de Chine, right sides together. Using the sewing machine, stitch slowly down each side in the direction of the pile. Next, stitch across the bottom, then stitch 15cm (6in) each side of the top edge, leaving a 6cm (2¼in) gap. Trim the corners and gently iron the seams before turning the scarf right-side out. Finish by closing the gap using silk thread and herringbone stitch.

2. Kikko folding is explained on pages 24–25. Make the first fold as shown. Then fold the whole equilateral triangle under.

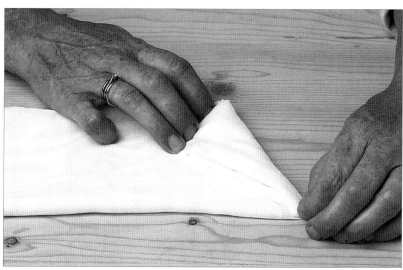

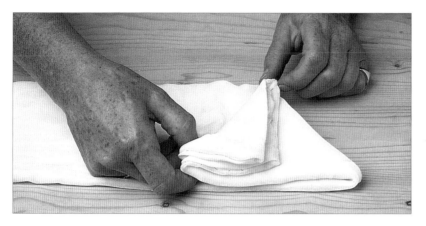
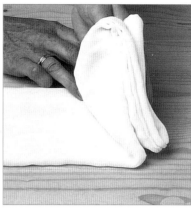

3. Turn over the whole scarf to reveal your folded over equilateral triangle. Fold this under along the diagonal, and turn over the whole scarf again.

4. Continue this process of turning over the scarf and folding the triangle backwards and under.

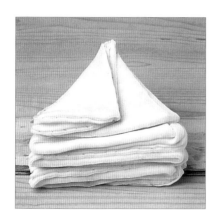

5. When you get to the end, you find yourself with half of an equilateral triangle left sticking out to one side. This is equal to the first fold you made, so fold it over to mirror your original fold.

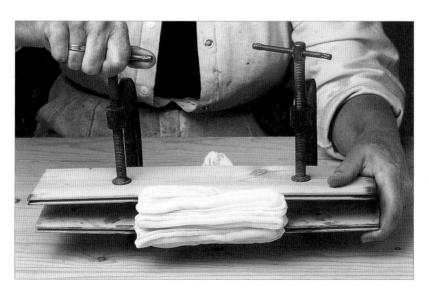

6. Use G clamps to clamp the folded scarf between two boards, ready for dyeing. Wetting the fabric before clamping will produce different patterns from wetting it after clamping. Loosely clamped cloth will take up more colour and give a bluer pattern than tightly clamped fabric, which will give you large areas of white crossed with fine blue lines.

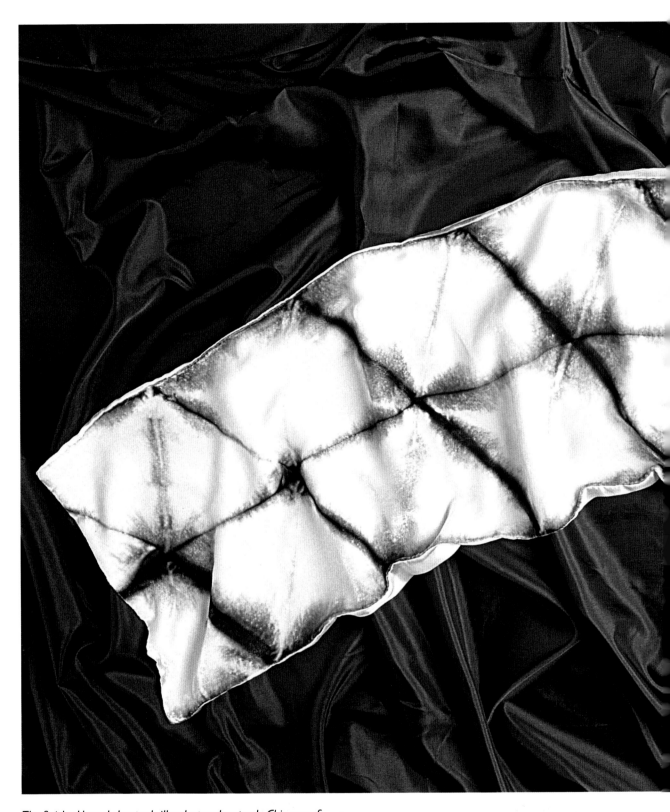

The finished board clamped silk velvet and crepe de Chine scarf.

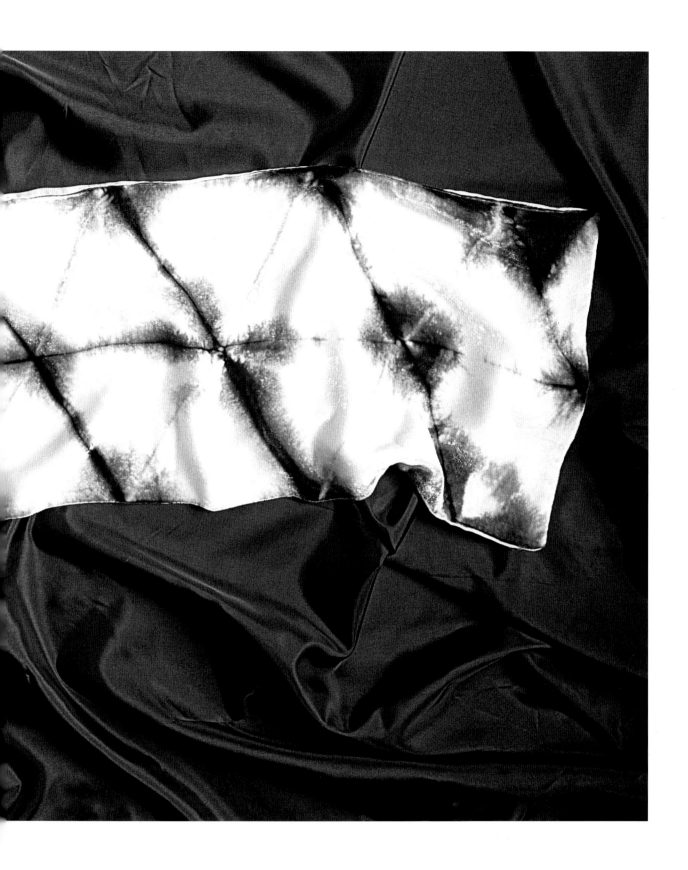

These scarves are made from silk muslin, crepe de Chine, habotai, silk crepe georgette, mousseline and knitted hemp, which have been variously stitched, clamped, folded, pleated and pole wrapped before indigo dyeing.

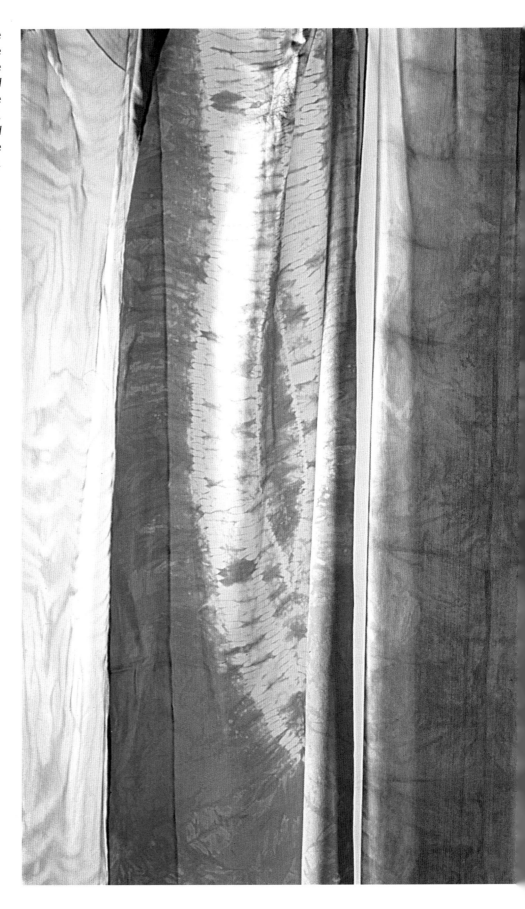

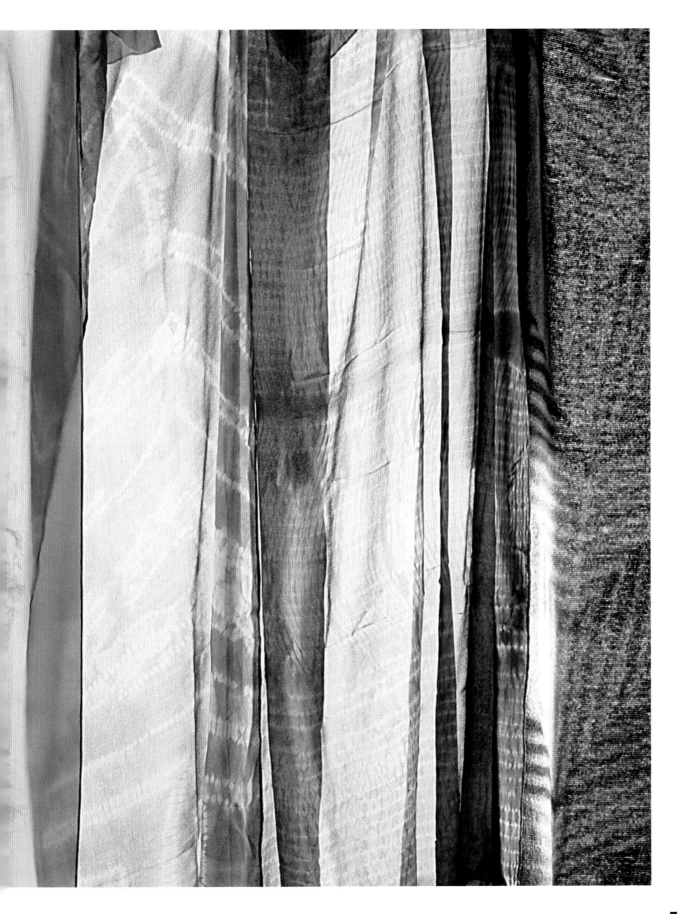

TEA COSY

I love my tea and a tea cosy is a must. The tea cosy shown on the left on page 83 is in constant use.

For this rectangular tea cosy, I used 38 x 56cm (15 x 22in) of flat satin silk, which allows for 1cm ($^3/_8$in) seams. I then used the resist method which involves rolling fabric around a core (in this case, rope), pushing it tight, dyeing, unrolling and air drying, then re-rolling from the next corner. This process is repeated from each corner, which results in a build-up of intricate patterns and subtly graded colour.

You can make your tea cosy to the dimensions I have given, or make one to fit your own teapot. To work out how much fabric you will need, measure the height and width of your teapot, add 2cm ($^3/_4$in) to each measurement and double the height. Cut the top fabric, wadding and backing fabric to this size. In this project I have cut the lining 2cm ($^3/_4$in) longer than the other fabrics to allow the bottom of the lining to form a trim. I use any appropriate needle size and thread for the decorative quilting. The core you use to roll the fabric around should be 10cm (4in) longer than the diagonal of the fabric. The larger the diameter of the core, the bigger the pattern will be.

You will need:

Core: length of flexible rope or garden hose

Strong thread or string for fabric resist

Silk thread for tacking and quilting

Needle, pins and scissors

Sewing machine

Flat satin silk, 38 x 56cm (15 x 22in)

Wadding and cotton backing fabric, 38 x 56cm (15 x 22in)

Lining: silk noil 38 x 58cm (15 x 22$^3/_4$in)

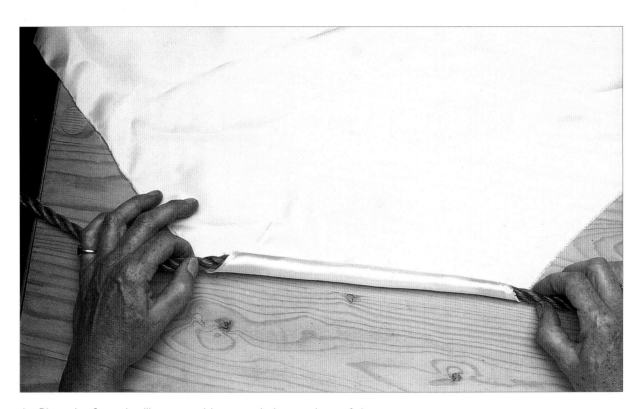

1. Place the flat satin silk wrong-side-up and place a piece of clean rope or garden hose diagonally across one corner. Roll the fabric up around the rope, rolling diagonally from corner to corner.

2. Knot a length of strong thread around one end of the rope and wind it loosely around the whole length of the fabric-wrapped rope. Tie it off at the other end.

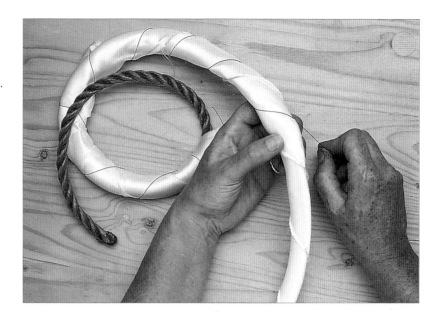

3. Push the fabric down the rope from each end so that it bunches together in the middle. Then make a loop from the rope and tie it in a secure knot as shown. The fabric is now ready for dyeing. Soak the fabric well and dip it for five minutes.

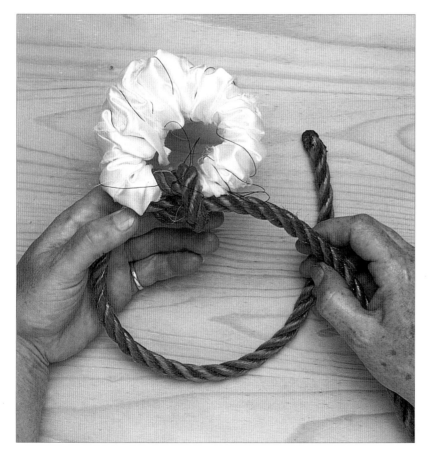

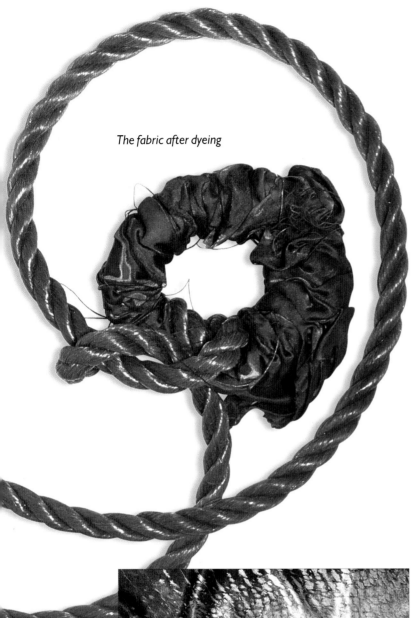

The fabric after dyeing

4. After dyeing, untie and unroll the fabric. Air dry it for half an hour. The picture shows the fabric after the first dip.

5. Roll the fabric around the rope again, starting from the next corner. Dip it again. Here you can see the effect achieved by the second dip.

6. Repeat the process, rolling from the third corner, and after air drying, roll from the fourth corner and dip again. The picture shows the fabric after the fourth dip.

7. Pin then tack the dyed and washed silk, wadding and cotton backing fabric together, and quilt through all three layers. After looking at the finished dyed pattern, I decided to hand quilt the tea cosy in simple decreasing rectangles. The pattern is shown on the right.

Quilting through all three layers

Top fabric

Wadding

Backing fabric

The quilting pattern

8. Fold the quilted fabric in half. With right sides together, pin, stitch and trim the side seams of the cosy, sewing through the dyed fabric, wadding and backing cotton. Fold the lining right sides together. Stitch the side seams of the lining, leaving a 10cm (4in) gap at the top of one side. Iron the seams open. With the lining wrong side out and the quilted cosy right side out, slip the cosy into the lining, matching up side seams. Pin the bottom seam and machine hem. Trim and press this seam, then turn the whole cosy through the gap in the lining. Close the gap with herringbone stitch. To finish off the cosy, ease and pin around the bottom edge and quilt through all layers. Fold the bottom of the lining over the seam allowance and quilt through the lining fabric.

Stitching and trimming the side seams of the lining

10cm (4in) gap

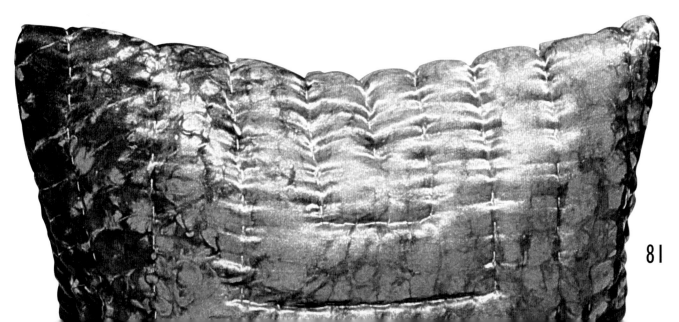

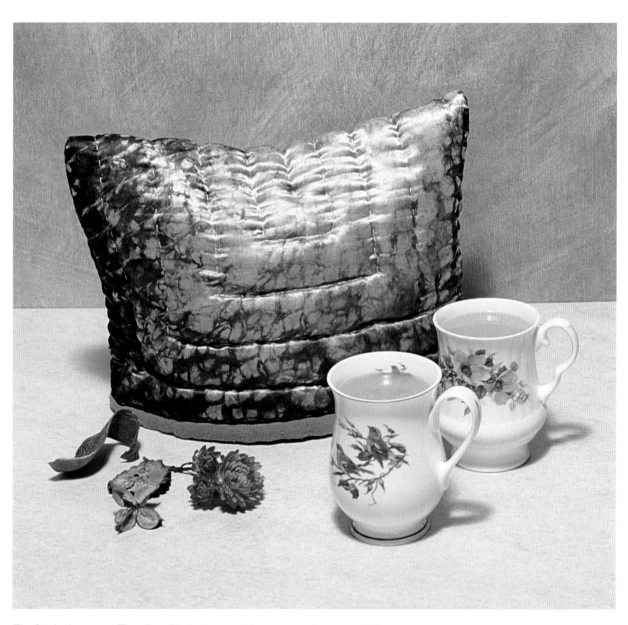

The finished tea cosy. The silk noil lining in a complementary colour sets off the shining blue of the indigo-dyed fabric.

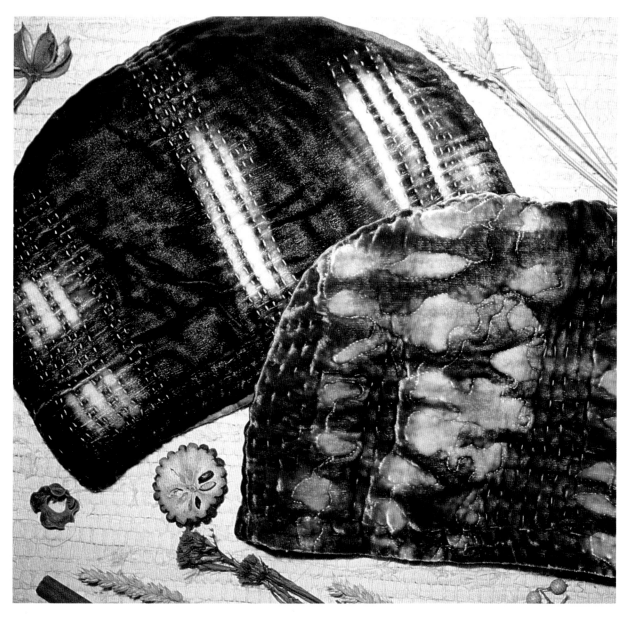

Variations on a theme. The top tea cosy shows an effective use of curtain track in a resist technique. For the other cosy, knotting the fabric before dyeing produced this cloud-like pattern, inspired by the view from my studio window.

BOG JACKET

This pattern was given to me by a good friend and inspiration. The name comes from the remains of garments found on preserved bodies up to 2,000 years old discovered in bogs in Europe. The jacket can be made from a single length of fabric, with just two seams, and is usually sewn by hand. The design is simplicity itself and can be customised easily by changing the style of neckline or the length of the sleeves and hem, or by adding pockets. If you are not used to making your own patterns, make a small paper jacket from a piece of A4 paper before starting. Mark the measurements for the sleeves, shoulder to bust and bust to hem on your paper pattern and use it as a guide to calculate how much fabric you will need.

 If your fabric is not wide enough for the length of sleeves you want, join fabric selvedge to selvedge and use this seam as the centre back of the jacket.

 There are two ways of making this jacket: you can dye the fabric first, then cut the pattern, or you can make up the jacket and then apply the resist and dye it, as has been done in the demonstration.

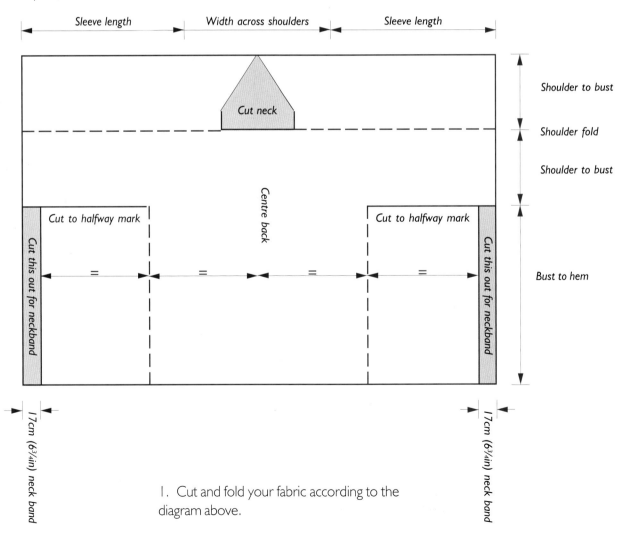

Sleeve length | Width across shoulders | Sleeve length

Shoulder to bust

Shoulder fold

Shoulder to bust

Cut neck

Centre back

Cut to halfway mark

Cut to halfway mark

Cut this out for neckband

Cut this out for neckband

Bust to hem

17cm (6¾in) neck band

17cm (6¾in) neck band

1. Cut and fold your fabric according to the diagram above.

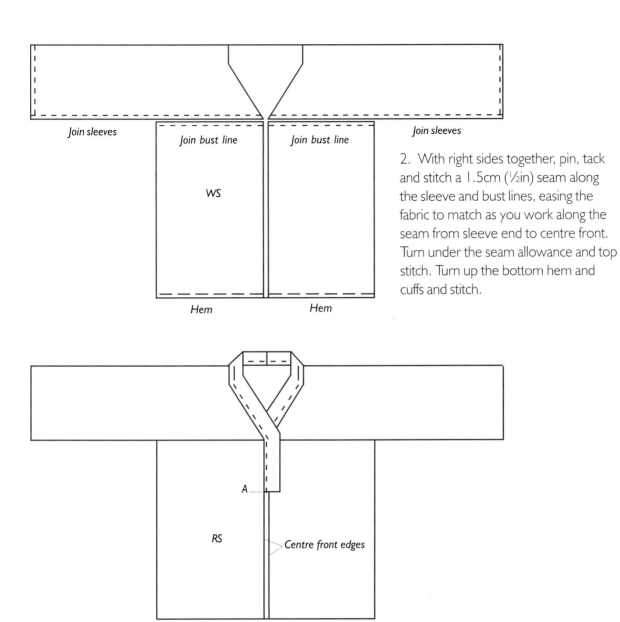

Join sleeves *Join bust line* *Join bust line* *Join sleeves*

WS

Hem *Hem*

2. With right sides together, pin, tack and stitch a 1.5cm (½in) seam along the sleeve and bust lines, easing the fabric to match as you work along the seam from sleeve end to centre front. Turn under the seam allowance and top stitch. Turn up the bottom hem and cuffs and stitch.

A

RS

Centre front edges

3. Turn the jacket right sides out. Place the two neck band pieces right sides together and stitch them at one end. Trim and iron the seam open. Fold the neck band lengthwise, right sides together, and stitch each end with a 1cm (½in) seam allowance. Trim the seams, turn the neck band right sides out and iron. Match the centre back of the jacket to the centre neck band seam and mark the end of the neck band (A) on the centre front. Turn in the centre front edges 1cm (½in) and hem up from the bottom hem to 0.5cm (¼in) above mark A. At this point make 1cm (¼in) horizontal snips each side into the jacket. Place the neck band in position with a 1cm (½in) seam allowance along the top edge. Make sure the ends cover the snipped fabric. Pin then tack the neck band along and around the neck. Stitch to secure all along the top edge. Trim the seam and iron upwards, then fold the neck band back over. Turn a 1cm (½in) seam allowance under, and pin and tack the fold to the seam line. Stitch 0.5cm (¼in) in from the seam through all layers.

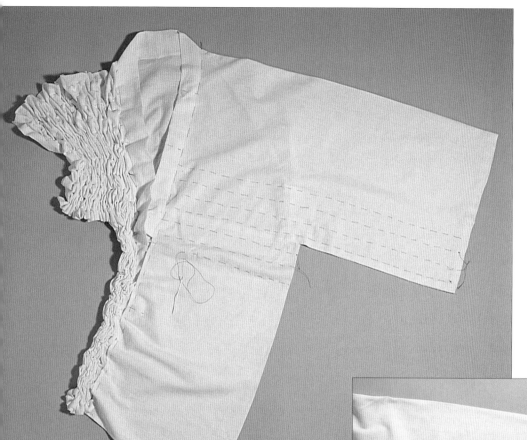

4. Lay the assembled jacket on a flat surface. Pin and then tack through the front and back, along the neck band and down the centre front. Prepare a mokume resist, as shown on page 27, but in a slightly different pattern. Using a strong polyester thread, stitch horizontal lines of running stitch from the top of the outstretched sleeves and right down the jacket to the bottom hem. Leave the neck band unstitched. Stitch through the double fabric and leave a loose end of thread at the end of each row. The stitches should be in staggered rows, with each stitch lined up with the gaps in the row above.

The staggered stitch pattern for the mokume shown on the sleeve.

5. When the pattern is stitched, pull up all the running stitches evenly across the jacket. Return and pull up all the rows again, very tightly. Knot off the loose threads in pairs. The jacket is now ready for dyeing.

The finished bog jacket. This simple pattern can be customised with pockets, a different neck line, collar or length, and of course with various resist patterns. Then there's the choice of fabric. Have fun!

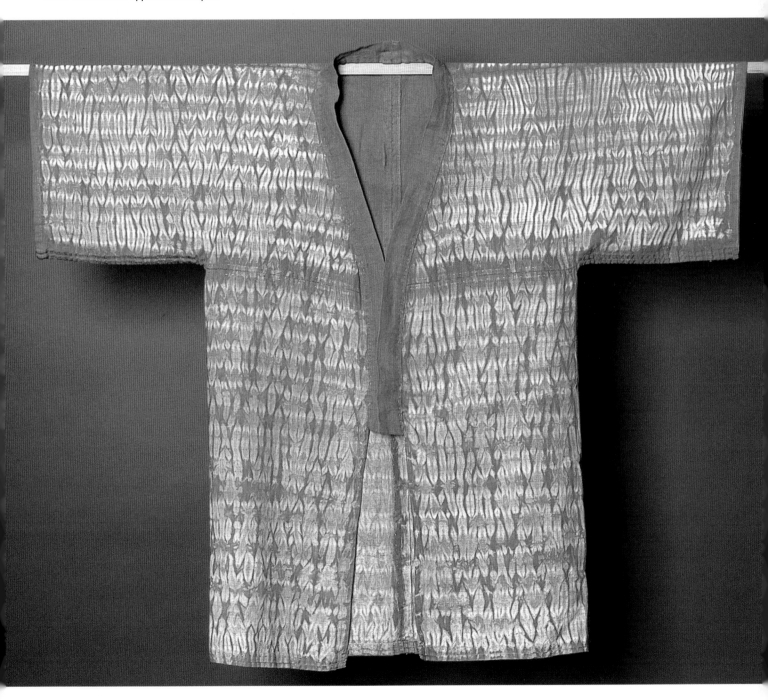

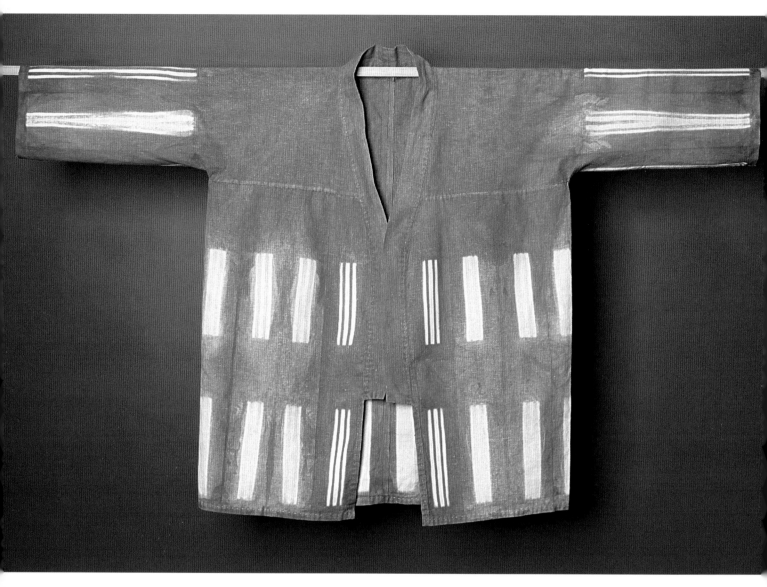

This short-sleeved linen jacket was clamped with curtain track before dyeing, to produce the distinctive stripes.

A long mercerized cotton kimono. The pattern over the shoulder was produced by stitching and binding. The lining is pleated shibori dyed silk.

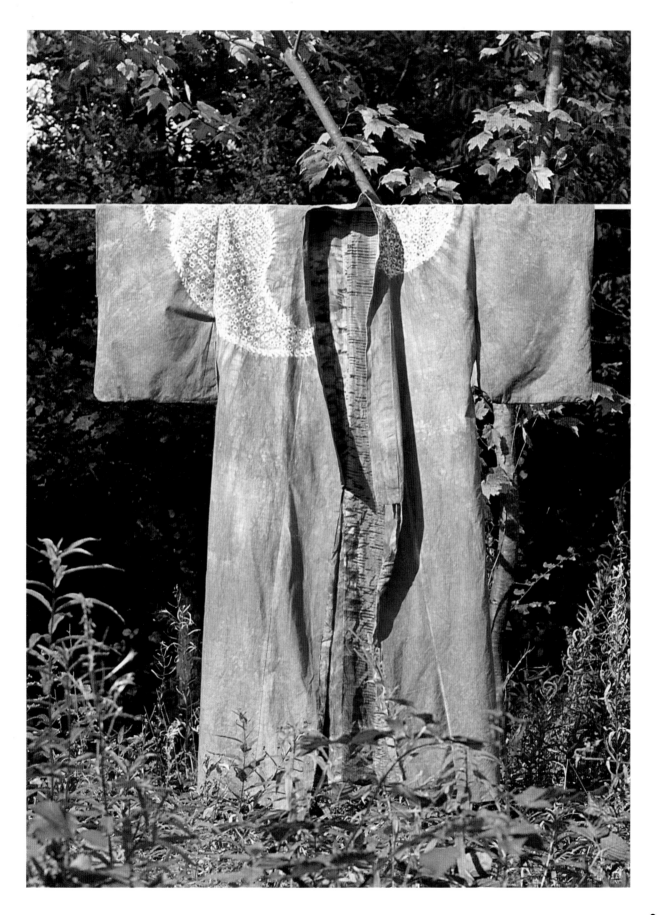

CUSHION

There is something very relaxing about holding a beautifully blue soft velvet cushion. This cushion has a zip, allowing the cover to be removed easily for washing.

The piece of fabric used to make this rectangular cushion was dyed using the Katano technique described on pages 40–41. I used the dyeing patterns on the fabric as the base for the quilting, which I did in white hand-stitching similar to sashiko. You can also quilt the cushion using a sewing machine.

You will need:

Katano dyed silk velvet,
44 x 108cm (17 x 42½in)
Wadding and cotton backing
fabric the same size
40cm (15¾in) concealed zip
Needle, silk thread and pins
Sewing machine
Cambric covered goose
down filling

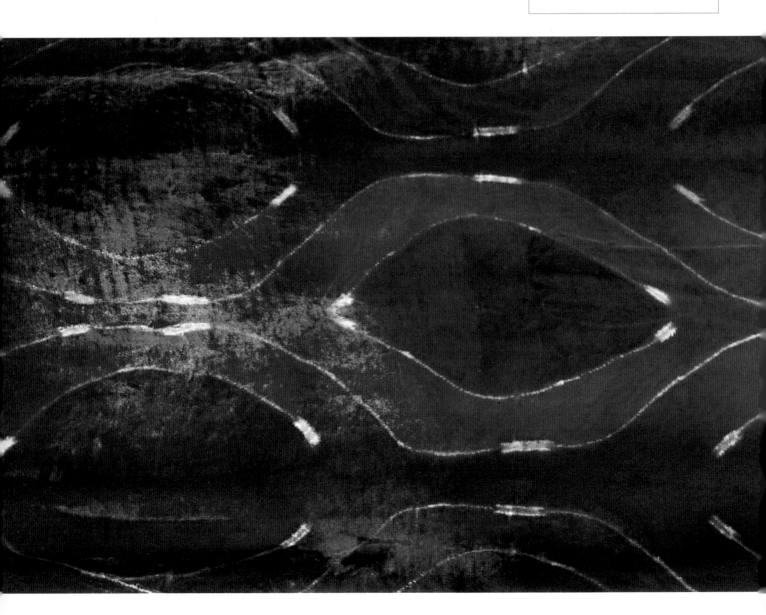

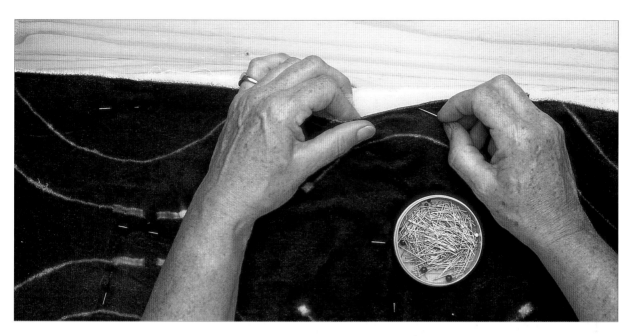

1. Take a piece of silk velvet dyed according to the instructions on pages 40–41. Pin the fabric to a piece of wadding and a piece of backing fabric the same size as the fabric, then tack all three together.

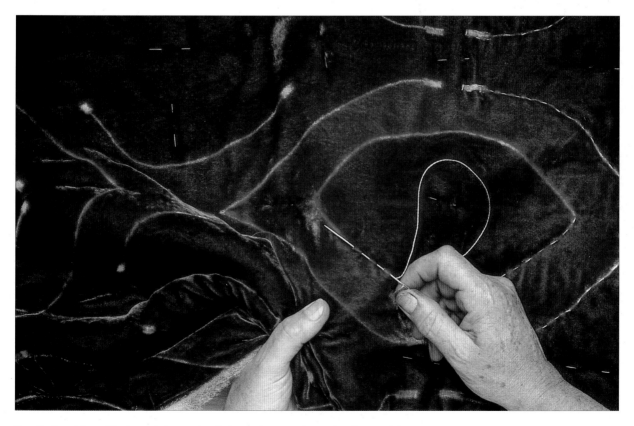

2. Quilt with a silk thread through all three layers, along the lines of the pattern produced by the dyeing process.

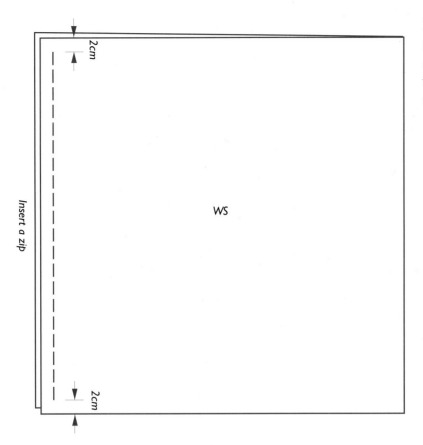

2cm

Insert a zip

WS

2cm

3. Fold the quilted fabric right sides together. Insert a zip centrally on the seam opposite the fold. Stitch the 2cm (¾in) either end of the zip.

4. The zip will be at the centre back of the cushion, as shown. Open the zip. Pin, tack and machine stitch the two open sides. Trim and finish the seams. Pull the cushion through the zip opening to the right side and insert a cambric covered goose down filling.

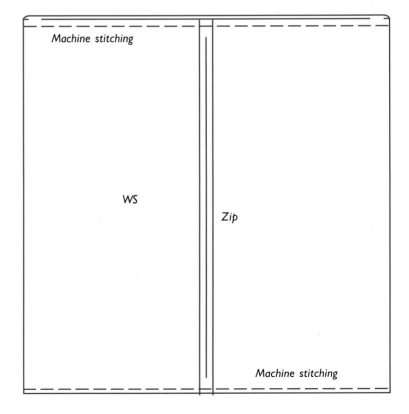

Machine stitching

WS

Zip

Machine stitching

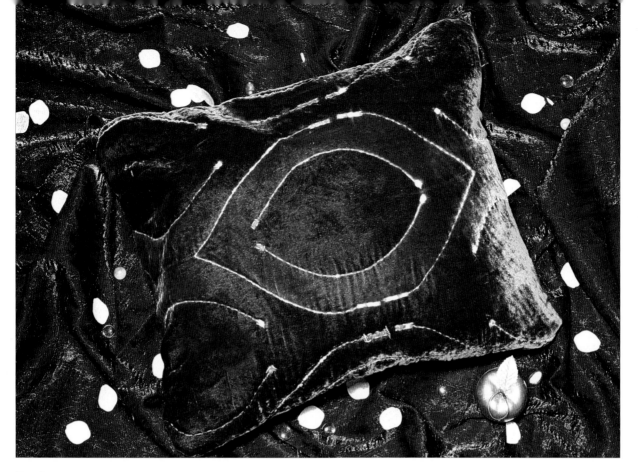

The finished cushion. The polyester resist works well with velvet, as the ghosting of the indigo is highlighted by the fall of light on the velvet.

Steve Tanner

Beached 'kooshns'! My name for these strange pyramid-shaped cushions was inspired by the phonetic spelling of the word 'cushions'.

93

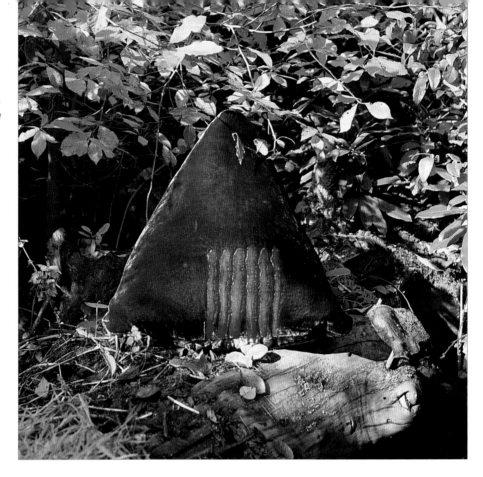

This cushion was made with stitch resist indigo dyed velvet, overdyed with fibre-reactive scarlet.

This spectacular quilt is 274 x 260cm (108 x 102in) and was made using a piece of silk velvet prepared using the Katano method. The dyed silk velvet was quilted with silk thread through all three layers: silk velvet, wadding and undyed silk noil backing, and was finished with a jumbo tubular wadding edge.

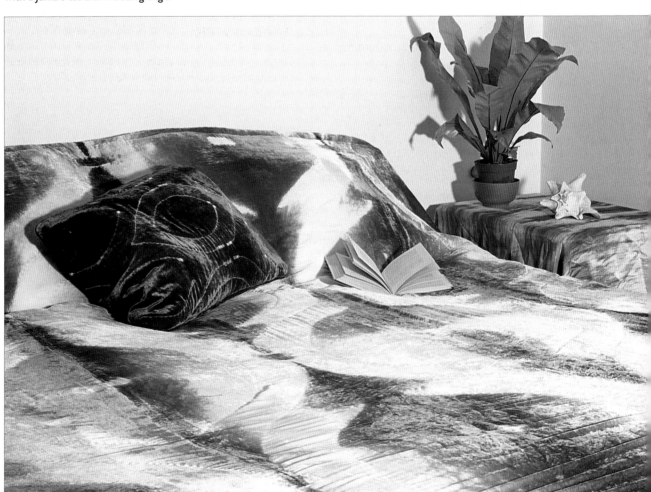

BIBLIOGRAPHY

Adrosko, Rita J., *Natural Dyes and Home Dyeing*, Dover, 1976, ISBN 0-486-22688-3

Balfour-Paul, Jenny, *Indigo*, British Museum Press, 1998, ISBN 0-7141-1776-5

Bosence, Susan, *Hand Block Printing and Resist Dyeing*, David & Charles, ISBN 0-7153-8524-0

Bronson, J. and R., *Early American Weaving and Dyeing*, Dover, 1977, ISBN 0-486-23440-1

Dean, Jenny, *The Craft of Natural Dyeing*, Search Press, 1994, ISBN 0-85532-744-8

Garfield, Simon, *Mauve*, Faber & Faber, 2000, ISBN 0-571-20197-0

Gillow, John and Sentance, Brian, *World Textiles*, Bulfinch Press, 1999, ISBN 0821226215

Green, David, *Fabric Printing and Dyeing*, MacGibbon and Kee, 1972, ISBN 0-261-63238-8

Mail, Anne, *Tie and Dye Made Easy*, Taplinger Publishing Co., 1972, ISBN 0-263-51710-1

Mohanty, B. C., Chandramouli, K. V., Naik, H. D., *Natural Dyeing Processes of India*, Calico Museum, Ahmedabad, 1987

Nea, Sara, *Tie-Dye*, Van Nostrand Reinhold Company, 1969, ISBN 0-7141-1776-5

Rathbun, William (Ed.), *Beyond the Tanabata Bridge: Traditional Japanese Textiles*, Thames & Hudson, 1993, ISBN 0-500-01586-4

Robinson, Stuart, *A History of Dyed Textiles*, MIT Press, 1970, ISBN 289,79644-X

Sandberg, Gosta: *Indigo Textiles, Technique and History*, Lark Books, 1989, ISBN 0937274402

Wadda, Rice and Barton, *Shibori, the Inventive Art of Japanese Shaped Resist Dyeing*, Kodansha International Limited, 1999, ISBN 0-7011-559-6

The following books are not so readily available but are very useful if you can get hold of them, perhaps from fellow enthusiasts, college libraries, second-hand bookshops or the Internet:

Barbour, Jane and Simmonds, Doig, *Adire Cloth in Nigeria*, University of Ibadan, 1971

Buhler, A., *Plangi – Tie and Dye Work*, CIBA Review No. 104

Eicher, Joanne Bubolz, *Nigerian Handcrafted Textiles*, University of IFE Press, ILE-IFE Nigeria, 1976

Japan Folk Crafts Museum, *MINGEI: The Living Tradition in Japanese Arts*, Kodansha International, 1991

Lesch, Alma, *Vegetable Dyeing*, Watson-Guptill Publications, 1971

Storey, Joyce, *The Thames and Hudson Manual of Dyes and Fabrics*, Thames and Hudson, 1978

Towry-Coker, Adunola and Similola, *Nigerian Textiles*, Commonwealth Institute

The Colour of Night, one of two wall hangings inspired by an amazing train journey I took in 1999 from Clama, Chile, across the Andes through the Solar de Uyuni to Oruro, Bolivia. On page 96 is The Colour of Day, the other wall hanging. Both are shibori resist indigo dyed silk velvet, overdyed with fibre-reactive dye.

INDEX